IMAGES
of America

SAPELO ISLAND

IMAGES
of America

SAPELO ISLAND

Buddy Sullivan

ARCADIA

First printed 2000.
Reprinted 2002, 2003.

Published by Arcadia Publishing
Charleston SC, Chicago IL, Portsmouth NH, San Francisco CA

Printed in Great Britain.

Library of Congress Catalog Card Number: 00-105295.

For all general information contact Arcadia Publishing at:
Telephone 843-853-2070
Fax 843-853-0044
E-Mail sales@arcadiapublishing.com

For customer service and orders:
Toll-Free 1-888-313-2665

Visit us on the internet at http://www.arcadiapublishing.com

CONTENTS

ACKNOWLEDGMENTS

Those already familiar with Sapelo Island will see that much of the material within the present volume is contained in my earlier work on the area, *Early Days on the Georgia Tidewater, The Story of McIntosh County and Sapelo*. Inasmuch as the ebb and flow of history is fluid and ever-changing, I have taken the opportunity in this new book to utilize additional photographs and information that add new insights to my earlier works on the subject.

Grateful appreciation is expressed to the Sea Island Company, Bill Jones III, and the Jones family for generously providing me access to the Howard E. Coffin collections and archives on deposit at Sea Island. The originals of many of the photographs in this book are contained in the Sea Island holdings, and the Jones family has been most gracious over the years to allow me the use of these images for publication in my various historical works on the area. Many of the original photos in the Coffin section (which comprises the largest segment of this book) were taken by Mrs. Lydia Parrish of St. Simons Island, a close friend of the Coffins. Some were taken by Howard Coffin himself.

Primary resource materials on R.J. Reynolds and his years on Sapelo are abundant both in Georgia and in North Carolina. However, I wish to express especial appreciation to the University of Georgia Marine Institute on Sapelo Island for its assistance in locating old photographs of Reynolds and the formative years of the institute. A special note of thanks goes to UGAMI librarian Laura Cammon for her help in digging through dusty old files about the institute compiled years earlier by her predecessor, Lorene Townsend.

It should be noted here that the author of this work has not been paid a fee for the preparation of the book, nor will he receive royalties, remuneration, or any other benefit from any proceeds derived from the sale of the book.

INTRODUCTION

Sapelo Island has a human history dating back over 4,000 years, featuring a parade of successive occupants, including Native Americans, Spanish missionaries, English pirates, African slaves, antebellum cotton planters, and northern industrialists. While the colonial and plantation history of this unique island is a fascinating story in its own right, the focus of this photographic study concerns an equally interesting period of Sapelo's past, spanning a period from 1912 to 1964.

At the end of the first decade of the 20th century, Howard Earle Coffin was an established pioneer in the automotive industry. He was born in West Milton, OH, in 1873 and attended the University of Michigan as an engineering student. Coffin built an automobile engine as early as 1899 and was later chief designer for Ransom Olds. Coffin and others established the Hudson Motor Car Company in 1909. As chief designer and engineer for Hudson, Coffin made his fortune in a very short time. He and company president Roy Chapin (1880–1936) achieved considerable publicity for their automotive contributions. There is a story that in the spring of 1914, Coffin and Chapin sketched out in the hard-packed beach sand of Sapelo the design for the 1916 Hudson Model Six-40. In 1911, Coffin attended the Vanderbilt Cup and Grand Prix motor races in Savannah. During this visit, he accepted an invitation for a hunting and fishing outing on Sapelo Island, one of Georgia's larger barrier islands, located about 50 miles south of Savannah. It was on this occasion that Coffin became captivated by the natural beauty of Sapelo and the Georgia coast, as well as the unique history of this mystical island.

A year later, in 1912, Coffin and his wife, Matilda (Teddie), completed the purchase and consolidation of various holdings on Sapelo for about $150,000. Sapelo became the Coffins' winter home, and, in 1913, they refurbished the old south end residence of antebellum planter Thomas Spalding, which had been partially restored as a hunting lodge in 1911 by a sportsmen's group from Macon, GA. Further improvements to Sapelo were interrupted by the U.S. entry into World War I. Coffin was appointed by Woodrow Wilson to the Council of National Defense, and later, he was head of the Aircraft Production Board, which evolved into the Army Air Corps before becoming the U.S. Air Force. Following the war, Coffin became active in the development of commercial aviation and was a founder of a company that later became United Air Lines.

In the early 1920s, the Coffins embarked on a complete restoration of the main house on Sapelo, literally starting from scratch and building upon the original foundations and tabby walls that antebellum planter Thomas Spalding had built nearly a century before. The house, complete by 1927, was symbolic of the opulent lifestyles of the wealthy in the 1920s. Coffin used the English spelling of his island, "Sapeloe," throughout his 22 years of ownership. As time went along, the island became practically self-sufficient. Coffin built a power generating plant on the south end, and he employed many of Sapelo's black residents in his various agricultural pursuits. Sea Island cotton was grown on the island in the early 1920s, until the boll weevil invasion ended the effort. In 1923, Coffin's young cousin, Alfred William (Bill) Jones (1902–1982), arrived and became island manager for Coffin's Sapeloe Plantation.

Some of the nation's most prominent business leaders, financiers, and political figures were guests of Howard and Matilda Coffin on Sapelo, particularly in the years following the restoration of the main house. Coffin was prominent in Republican politics and it was thus fitting that President Calvin Coolidge and the first lady, Grace, were guests on Sapelo for a week during Christmas and New Year's of 1928–29. Coolidge's successor, Herbert Hoover, concluded his term with a one-day visit to Sapelo at Christmas of 1932. Aviator Charles A. Lindbergh visited Sapelo in February 1929, landing his single-engine plane in a cow pasture a short distance from the main house.

By 1926 Coffin had begun to turn his attention to other ventures. Coastal Georgia had been in a severe economic depression in the years before and after World War I. The construction of a causeway from Brunswick to St. Simons Island in 1924 inspired Coffin to initiate projects that he felt would attract increasing numbers of visitors to the region. This was primarily in light of the increasing availability of the automobile to people, as well as projected plans to pave U.S. 17 along the coast. Coffin spent a fortune on the development of St. Simons and Sea Island. Buying up former plantation lands on St. Simons, he built a yacht club and a golf course, paved roads, brought in telephone systems and electric power, and, almost as an afterthought, acquired a 5-mile beach strip called Glynn Isle. This he renamed Sea Island Beach, and it ultimately became the scene of his greatest contribution to the coast: the Sea Island Company and its signature project, the Cloister Hotel resort, designed specifically to attract affluent, well-heeled visitors to the Georgia coast. Assisted by the energetic Bill Jones, Coffin engaged famous Palm Beach architect Addison Mizner to design the Cloister. It opened in the fall of 1928. To encourage people to come to Sea Island, Coffin and Jones started a bus line running between Brunswick and Jacksonville, FL, and improved the causeway to St. Simons.

In all, Coffin invested some $3 million into his Georgia operations (not counting Sapelo). Much of this money had been borrowed against his stock market investments and real estate ventures. When the crash came in late 1929 with the subsequent Great Depression, Coffin was virtually wiped out. He faced bankruptcy, and the new Cloister project was in danger of going under. Another blow occurred when his beloved wife, Teddie, died in February 1932. Coffin turned over all of his personal and business affairs to Bill Jones, including the sale of Sapelo to R.J. Reynolds in the spring of 1934. The sale of Sapelo helped keep the Cloister afloat through the difficult financial times. Later, Coffin impulsively married a much younger woman, Gladys Baker, in June 1937, realized his mistake, and asked Jones to arrange a divorce. In November 1937, at the home of Bill and Kit Jones on Sea Island, Coffin took his own life. He was 64 years old. His life ended tragically, but he nonetheless left a lasting legacy to the coast: he ended forever the remoteness of the region by providing the means and amenities to attract visitors and brought the area into the national awareness.

R.J. Reynolds owned Sapelo from 1934 until his death in 1964. He made a number of improvements and modifications on South End Mansion and engaged muralist Athos Menaboni to render a series of wall paintings in various sections of the house. In the late 1930s, Reynolds built a farm and dairy complex on the south end and, like Coffin, utilized Sapelo for timbering and cattle operations.

The greatest legacy left by Reynolds was the creation of the Sapelo Island Research Foundation (1949) and the subsequent development, under his auspices, of the south end complex into a marine research laboratory by the University of Georgia. In the 1950s and 1960s, the institute established an international reputation for its scientific ecological and estuarine research, conducted primarily in the marshes and tidal creeks around Sapelo Island. Scientists such as Eugene P. Odum, Larry Pomeroy, and John Teal laid the foundation in the early years of the UGAMI for the path-breaking research that led to increased understanding of the role played by the Georgia salt marshes, *Spartina alterniflora,* in the coastal environment.

In two separate transactions, in 1969 and 1976, the widow of Reynolds, Annemarie Schmidt Reynolds, sold Sapelo Island to the state of Georgia, which now manages and administers most of the island today for scientific research and estuarine educational opportunities.

One

THE LEGACY OF
THOMAS SPALDING

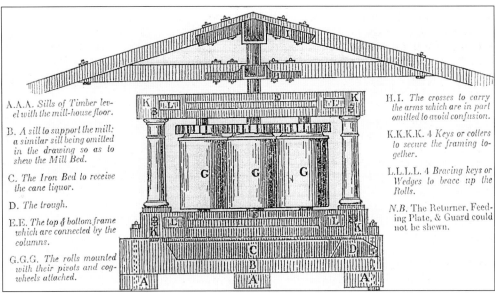

A.A.A. *Sills of Timber level with the mill-house floor.*

B. *A sill to support the mill: a similar sill being omitted in the drawing so as to shew the Mill Bed.*

C. *The Iron Bed to receive the cane liquor.*

D. *The trough.*

E.E. *The top & bottom frame which are connected by the columns.*

G.G.G. *The rolls mounted with their pivots and cogwheels attached.*

H.I. *The crosses to carry the arms which are in part omitted to avoid confusion.*

K.K.K.K. *4 Keys or cotters to secure the framing together.*

L.L.L.L. *4 Bracing keys or Wedges to brace up the Rolls.*

N.B. *The Returner, Feeding Plate, & Guard could not be shewn.*

Thomas Spalding (1774–1851) purchased 5,000 acres on the south end of Sapelo Island in 1802, completing a transaction begun by his father-in-law, Richard Leake. Spalding initiated ambitious plans to build an agricultural empire on Sapelo. One of his earliest innovations was the cultivation of sugar cane and the manufacture of sugar at his own sugar mill. Spalding built a tabby sugar cane press to his own design, including the machinery to operate the press. The drawing is Spalding's own, done *c.* 1816.

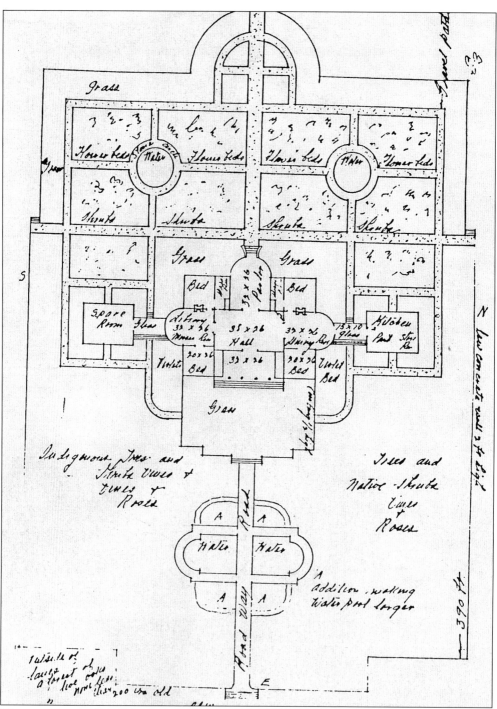

The most noticeable architectural legacy left by Thomas Spalding on Sapelo is South End House, his permanent family estate built by slave labor under the supervision of Roswell King from 1807 to 1810. South End House was the fullest expression of Spalding's great sense of permanence and featured a symmetrical layout of gardens, paths, live oak groves, and pools to the front and rear of the house.

Thomas Spalding was the consummate agriculturist, the essence of the scientific farmer. His skillful plantation management and humane treatment of his slaves made him one of the leading planters on the south Atlantic tidewater. An enthusiastic experimenter, the resourceful Spalding grew Sea Island cotton and sugar cane as his primary cash crops on Sapelo. This c. 1845 portrait is attributed to John Maier; it was done when Spalding would have been about 70 years of age.

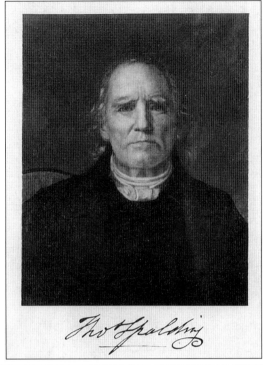

In its day, South End House was one of the finest estates of coastal Georgia. It was built of 2-foot-thick tabby walls to withstand even the most severe hurricanes (which it did in 1824). The house was built to Spalding's own design and apparently incorporated features of the Virginia home of Thomas Jefferson, Monticello, which Spalding is known to have visited during a term in the Senate while Jefferson was president.

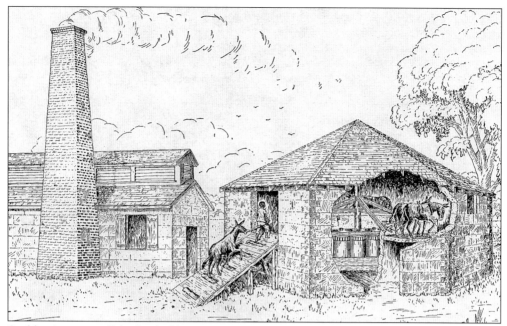

Spalding's sugar-mill, built of tabby in 1809–10, was both animal and tidal powered. It was built on Barn Creek and was the first facility of its kind in Georgia. Spalding, who freely shared his agricultural ideas and methods, consulted with his contemporary planters in the construction of similar mills in other coastal counties.

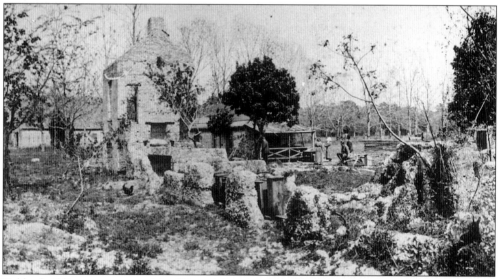

Tabby buildings, constructed by Edward Swarbreck c. 1819 at Chocolate plantation on the north end of Sapelo, reflect the Spalding method. Swarbreck (1760–1844) owned part of the north end and was an associate of Spalding. Tabby ruins at Chocolate include the main house, barn, slave quarters, and outbuildings. There were four cotton plantations on Sapelo: South End (Spalding), Kenan (Michael J. Kenan, son-in-law of Spalding), Chocolate (Charles Rogers, later Randolph Spalding) and Raccoon Bluff (Street/Kimberly). The 1860 census showed the Spaldings with 252 slaves in 50 dwellings on the south end and at Chocolate, and Kenan with 118 slaves in 27 houses, for a total of 370 slaves on Sapelo.

Sapelo's north end entailed multiple ownership following its sale by agents of a French consortium starting about 1800. John Montalet (1760–1814), a French refugee from the slave revolt on Haiti, owned High Point. This tract was later owned by Gen. Francis Hopkins (until his death in 1821) and later by Edward Swarbreck, proprietor of Chocolate. Montalet, Hopkins, and Swarbreck all grew cotton and owned slaves. Charles Rogers owned much of the north end through purchase from Swarbreck. Rogers sold this portion of the island to Thomas Spalding *c.* 1843. Spalding awarded Chocolate to his youngest son, Randolph Spalding (1822–1862).

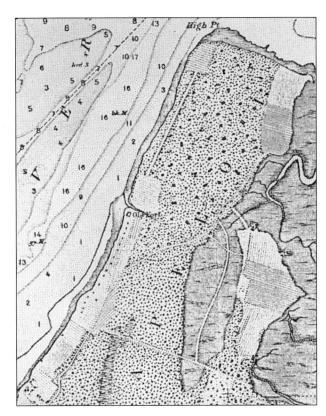

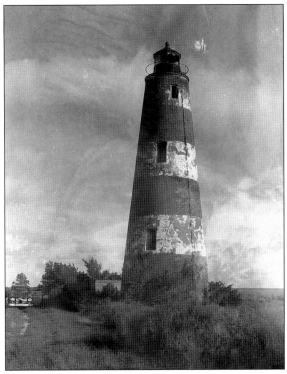

In 1820, the brick lighthouse was built on the south end of Sapelo, overlooking the shallow waters of Doboy Sound. It was built on land donated to the federal government by Thomas Spalding to guide shipping into the growing seaport of Darien.

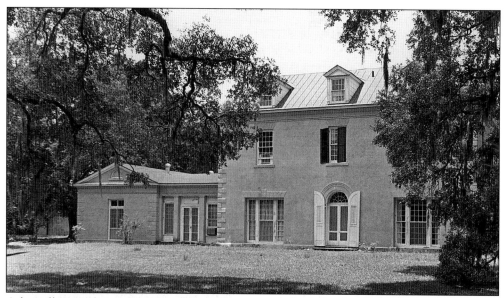

Ashantilly was the mainland home of Thomas and Sarah Leake Spalding. It was built just outside Darien *c.* 1821. Spalding owned considerable acreage on the mainland, including a rice plantation in the Altamaha delta (Cambers Island), Black Island near Ashantilly, the Thicket 7 miles north of Darien, where he operated a sugar mill and rum distillery with William Carnochan from 1816 to 1824, and land on Hutchinson Island at Savannah.

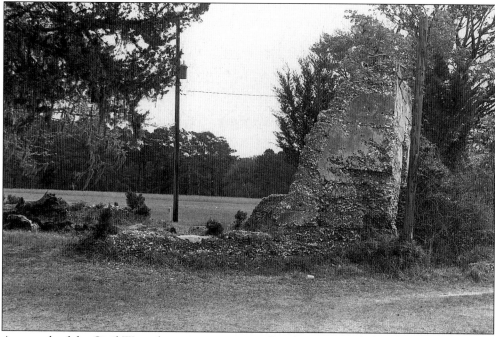

As a result of the Civil War, plantation activity on Sapelo came to a halt. The tabby sugar mill fell into ruins and the cotton fields lay fallow. About 370 Spalding family slaves were on Sapelo at the time of the war. With emancipation, many of the freedmen remained on the island and began developing their own communities and small-scale agricultural operations. After the war, Spalding heirs lived in the vicinity of the Barn Creek sugar mill, then called Riverside.

During the Reconstruction and postbellum periods, Sapelo's south end was inhabited by three of Thomas Spalding's grandchildren. Pictured is Archibald C. McKinley (1842–1917), who married Sarah, daughter of Randolph and Mary Bass Spalding. The McKinleys moved to Sapelo in 1870 and were still living there at Barn Creek when Howard Coffin bought the island in 1912. McKinley, with his brothers-in-law, Thomas Bourke Spalding (1849–1884) and Thomas Spalding II (1847–1885), engaged in cattle raising, selling the beef to shipping that arrived at Doboy to load timber and lumber. The three men operated a small steamboat service between Sapelo, Doboy, and Darien. Steamboat lines also utilized the dock at High Point on the north end in the 1870s.

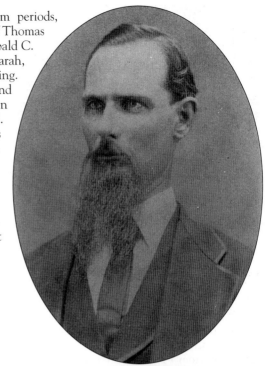

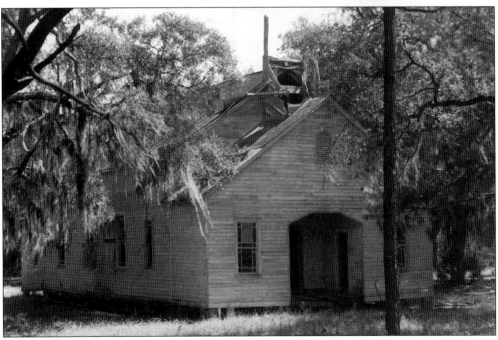

The largest freedmen's settlement on Sapelo developed at Raccoon Bluff, formerly known as the Street Place, on the east side of the island. The 1,000-acre tract (the only part of Sapelo never owned by Thomas Spalding) was sold in 1871 to the William Hillery Company and became the first black-owned land on Sapelo (see Chapter 4). Shown is the First African Baptist Church, which was built in 1900 at Raccoon Bluff. It is still standing.

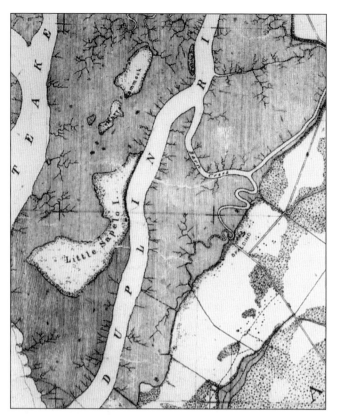

This 1868 U.S. Coast Survey topographic map delineates the Barn Creek-Marsh Landing section of Sapelo. It shows the lower Duplin River and Teakettle Creek, tidal streams that flow on the west side of the island. A.C. McKinley owned 100 acres on Barn Creek near the old Long Tabby sugar mill. T. Bourke Spalding owned the Marsh Landing tract near the Duplin, where he lived with his wife, Ella Barrow Spalding. His brother, Thomas Spalding II, owned the south end around the family's antebellum home.

South End House was badly damaged during the Civil War. The heirs of Thomas Spalding had no resources with which to restore the house after the war; thus, it gradually fell into ruins during the remainder of the 19th century.

The Cromley family, lighthouse keepers at Sapelo, engaged in rattlesnake hunts in the 1880s and 1890s. These unusual events received wide publicity, including this 1891 article in the *Atlanta Constitution*.

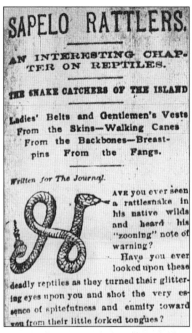

SAPELO RATTLERS.

AN INTERESTING CHAPTER ON REPTILES.

THE SNAKE CATCHERS OF THE ISLAND

Ladies' Belts and Gentlemen's Vests From the Skins—Walking Canes From the Backbones—Breastpins From the Fangs.

Written for The Journal.

AVE you ever seen a rattlesnake in his native wilds and heard his "zooning" note of warning?

Have you ever looked upon these deadly reptiles as they turned their glittering eyes upon you and shot the very essence of spitefulness and enmity toward you from their little forked tongues?

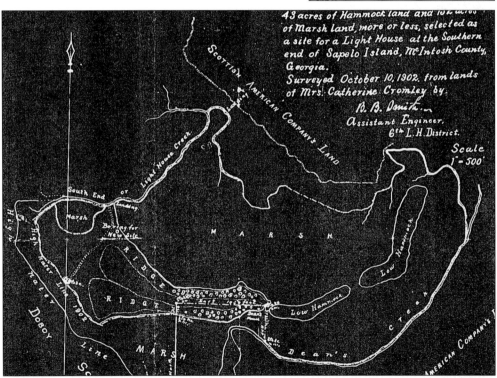

43 acres of Hammock land and 102 acres of Marsh land, more or less, selected as a site for a Light House at the Southern end of Sapelo Island, McIntosh County, Georgia.
Surveyed October 10, 1902, from lands of Mrs. Catherine Cromley by
B. B. Smith,
Assistant Engineer,
6th L.H. District.
Scale
1" = 500'

A survey for a new steel lighthouse, a short distance from the 1820 brick tower, was taken in 1902 on the south end of Sapelo. The lighthouse island was then owned by the Cromley family, having been sold to James Cromley in 1875 by Thomas Spalding II. The Cromleys later sold 182 acres of the lighthouse island to the federal government in 1904, and the new steel lighthouse was built a year later.

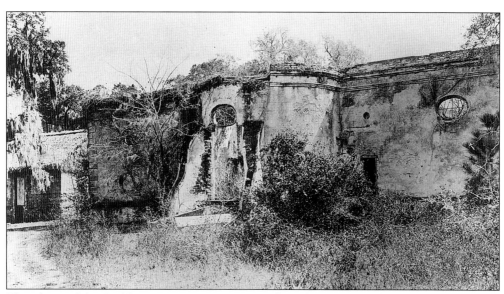

This photo of the Spalding mansion in ruins was taken about 1900. Before his death in 1885, Thomas Spalding II and his wife lived in a smaller house built near the ruins. The Spalding heirs entertained various proposals for the sale or lease of the 5,000 acres they still owned on the south end of Sapelo. These proposals included a lease to the state of Georgia for a penitentiary (1897), a resort hotel (1886, 1893, 1898), and a Methodist retreat (1905). None of these ever materialized.

RECOLLECTIONS of SAPELO.

BY A DARIENITE.

"South End."

"A ruined, lonely tabey house
 Stands in a silent grove,
And grayish moss hangs o'er it,
 By giant oak trees woye.
Bleak and crumbling is the house,
 Full desolate and tenautless—
A dark old wreck of happier days,
 And hospitable, now shelterless.
Once proud and grand, memorial like.
 A pile that never may revive.
The age that reared its mould is gone,
 And gone the power that could contrive.
Old ocean laves its island seat,
 Land of the olive and the vine,
And waves that mount and winds that crash
 In vain were hurled against its prime.
What memories crowd those vacancies,
 How oft we fill them as of yore,
How strives the present with the past,
 To be, to have, and nothing more."

An 1889 poem in the *Darien Timber Gazette* is a fitting elegy to the ruined South End House. Thomas Spalding II's widow, Sarah Barrow McKinley Spalding, married William C. Wylly, who died in 1897. Sapelo's south end went into foreclosure in 1900 to the Scottish American Mortgage Company. In 1910, the Sapelo Island Company of Macon, GA, acquired the south end and set about partially restoring the Spalding house for use as a hunting lodge.

Two

ENTER HOWARD
EARLE COFFIN

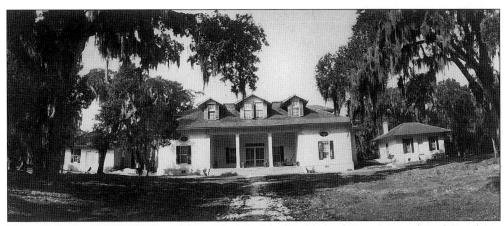

Howard Coffin (1873–1937) and his wife, Matilda (Teddie) of Detroit, purchased Sapelo in 1912. They consolidated the various holdings on the island, including the south end from the Sapelo Island Company (T.H. Boone of Macon); the Marsh Landing tract, owned by the heirs of Charles O. Fulton of Darien; the Kenan tract near the Duplin River from the heirs of Michael J. Kenan and Spalding Kenan, which had been under lease for oyster and timber rights in the 1890s and 1910s; and the north end, which since 1881 had been owned by Amos Sawyer (1830–1913), a soap manufacturer from Northampton, MA. Sawyer's sister Priscilla was married to David C. Barrow Sr., one of the relatives through marriage of the Spalding family. The north end had been Spalding property but was sold in 1866 by Mary Bass Spalding, widow of Randolph Spalding, to John N.A. Griswold (1821–1909) of New York. The photo of South End House is how the structure appeared when the Coffins arrived in 1912. This was the result of a partial restoration by the Macon sportsmen's group.

The *Savannah Morning News* took note of the Coffins' purchase. Howard Coffin was vice president of the Hudson Motor Car Company and a contemporary of Henry Ford as an automotive pioneer. He was a leading Republican, served as president of the Society of Automotive Engineers, and was on several national boards during World War I, assisting the War Department to improve national military preparedness. Coffin also promoted commercial aviation development and, in 1925, was president of a company that later became United Air Lines.

From the front porch of South End House in 1912, one had a view down the shell walk toward Nannygoat Beach.

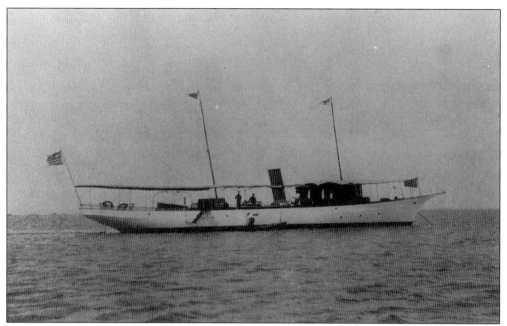

The steam yacht *Sapeloe,* as shown in 1912, exemplified Coffin's interest in boats of all sizes and types.

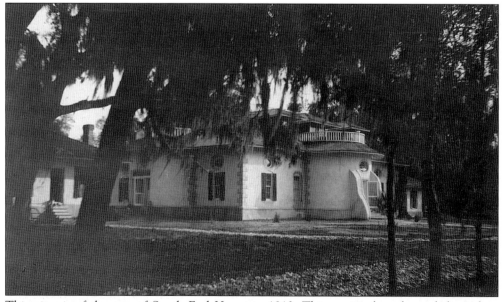

This view is of the rear of South End House in 1913. This section later housed the indoor swimming pool when the Coffins rebuilt the house, 1922–25. To the left is the kitchen wing, in the same part of the house it had been in the Spalding era.

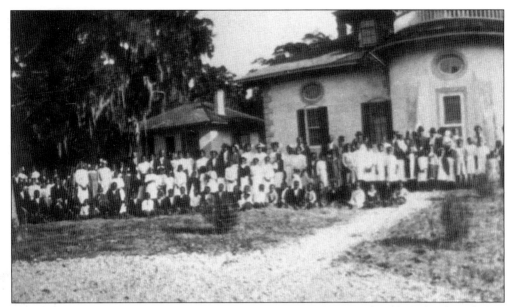

It was typical of the Coffins during their years on Sapelo to invite the island's African-American residents to the "big house" on special occasions. This picture was taken at Christmas in 1913, the Coffins' second year on the island.

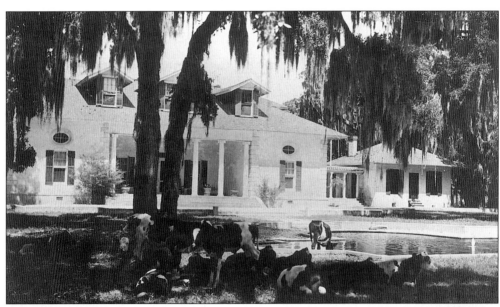

The Coffins had the outdoor pool built in front of the house about 1916. The pool is shown here as a source of water for some of the cattle that roamed at open range about Sapelo during the period. Although Coffin attempted to sell the house and surrounding property prior to 1920, he ultimately decided to undertake a complete restoration, which began in 1922 (see Chapter 6).

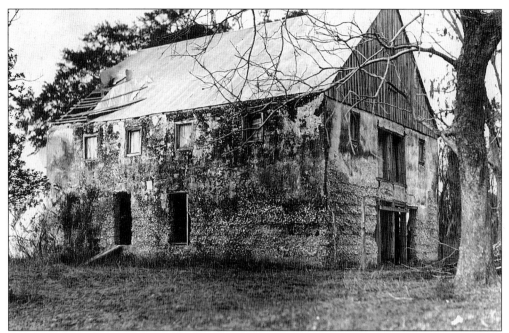

The barn at Chocolate was originally built of tabby in 1837 by Charles Rogers, owner of the north end at that time. This picture was taken of the structure prior to a partial restoration by Coffin in 1927. The barn was used by Coffin, and later by R.J. Reynolds, to stable horses and in conjunction with livestock operations on the north end.

The tabby foundation ruins at High Point apparently were part of the house built on the site by John Montalet during his residence on the north end of Sapelo from 1805 until his death in 1814. During the Reconstruction, John Griswold rebuilt the house on these foundations, which was occupied for a time (1871) by A.C. and Sarah Spalding McKinley before their permanent move to Post Office (Barn) Creek.

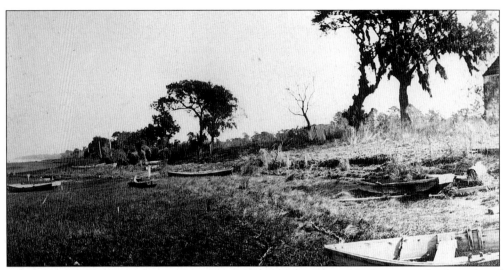

This is the boat landing at Chocolate at low tide, *c*. 1920. The tabby barn is at the far right of the photograph. The wooden boats are probably oyster bateaux utilized by Sapelo's African-American residents.

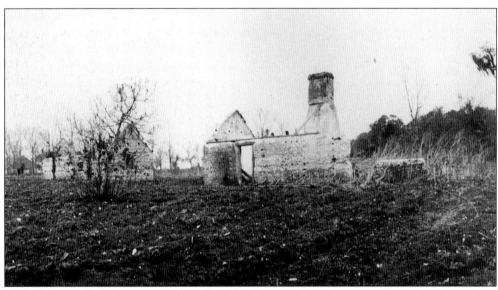

This photograph of the ruins of tabby slave dwellings at Chocolate plantation was taken about 1920. Many of these ruins are still standing today. Howard Coffin planted pecan trees along the lane leading into Chocolate from High Point (West Perimeter) Road.

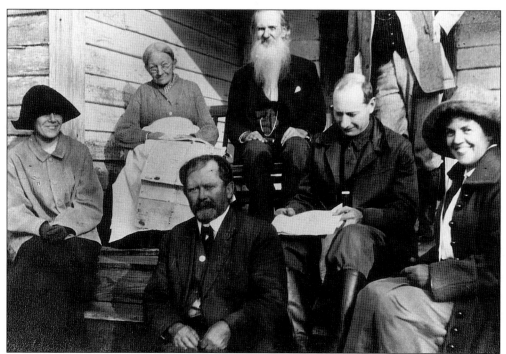

Archibald and Sarah Spalding McKinley, the elderly couple at the top of this picture, were the only Spalding family members still living on Sapelo at the time of Howard Coffin's purchase of the island in 1912. Mr. and Mrs. Coffin are shown at the right on the steps of the McKinleys' home on Post Office Creek near Long Tabby. Charles Bass, a cousin of Sarah and also a resident of the Long Tabby area, is in the foreground. Sarah was postmaster of Sapelo from 1891 until her death in 1916. A.C. McKinley died in 1917.

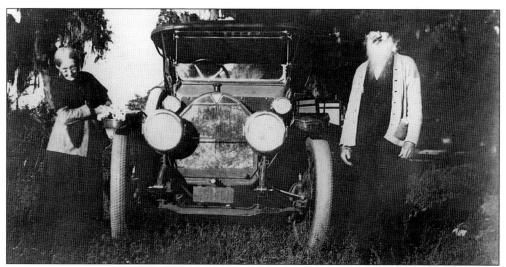

"Rapid transit" has come to Sapelo in this photo of Sarah and A.C. McKinley. Coffin purchased the 100 acres at Long Tabby owned by the McKinleys but allowed them to continue to live in their home until their deaths. The McKinley house is still standing.

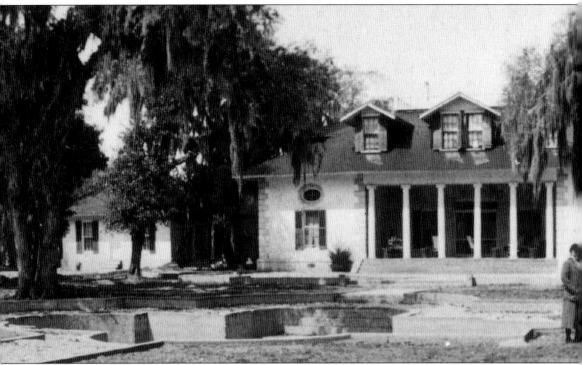

Horseback riding was a favorite pastime for the Coffins and their guests on Sapelo during the years prior to World War I. This view depicts the south end house with the newly installed

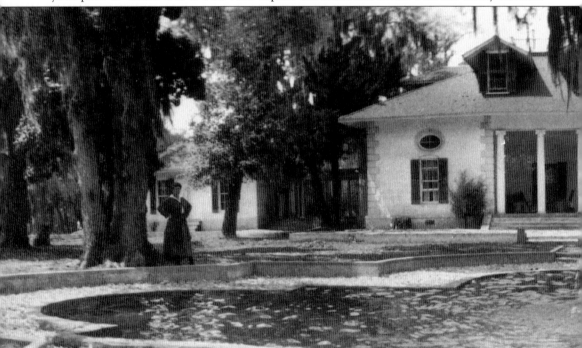

These unidentified guests are shown enjoying the outdoor pool at the Coffins' south end residence. Note that the house has six white columns in front, as did the antebellum Spalding

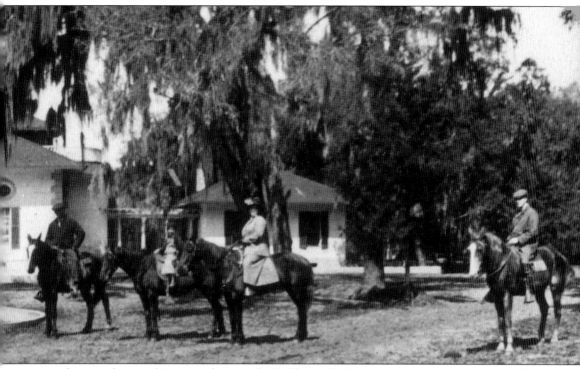

cruciform outdoor pool. Prior to the war, the Coffins utilized Sapelo as their winter home while continuing to maintain a residence in Grosse Point, MI.

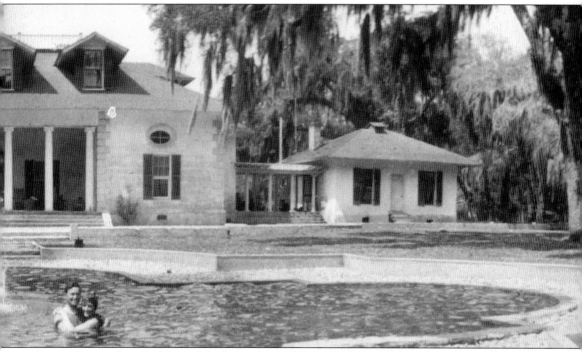

house. During the rebuilding of the house from 1922 to 1925, two of the columns were dropped by architect Albert Kahn, leaving the four that remain to this day.

The Long Tabby sugar mill was only a ruin when Howard Coffin undertook its restoration in 1922. The cane press is to the left hidden by the live oak tree. Behind the tabby sugar house

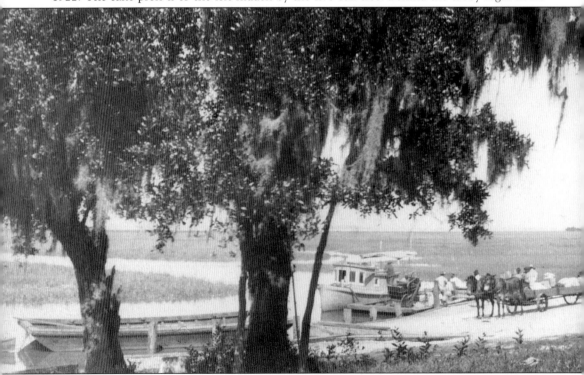

The south end dock on Sapelo Island, shown here about 1920, was the predecessor of Marsh Landing as the main dock. This dock was apparently located on South End Creek near the

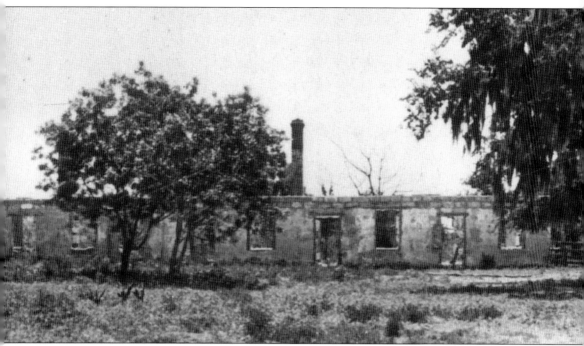

were the expansive agricultural fields that once yielded Sea Island cotton and sugar cane on Thomas Spalding's antebellum plantation.

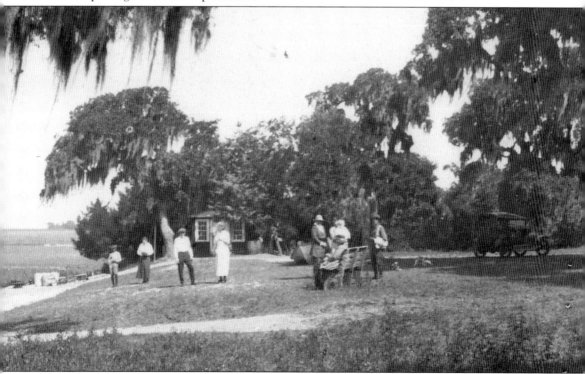

present Marine Institute site. Note the horse-drawn dray near the boat landing and the vintage automobile on the right side of the photograph.

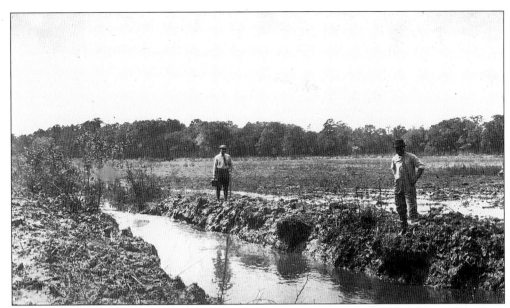

Howard Coffin undertook extensive irrigation operations on the island preparatory to his efforts to revive the cultivation of crops. In several instances, he improved on drainage ditches built by Thomas Spalding a century earlier.

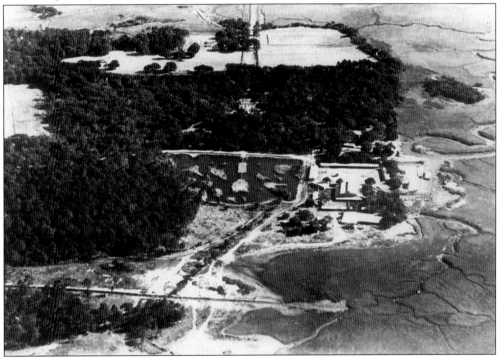

This aerial view of the south end of Sapelo Island was taken about 1924 and reveals the extent to which Coffin had altered the landscape up to that point. In the middle of the picture is the man-made water garden still under construction. Just to the right of the water garden is Coffin's farm complex on the present site of the Marine Institute. To the right are salt marshes penetrated by tidal creeks.

Three

THE TRANSFORMATION
OF AN ISLAND

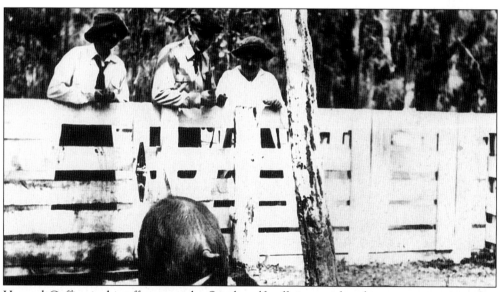

Howard Coffin, in his effort to make Sapelo self-sufficient and perhaps even turn a modest profit, injected his usual energy and resourcefulness into developing the island into an enterprise reminiscent of antebellum plantation days. The Coffins are shown here at "Hog City," a scene of livestock activities not far from the south end residence. During the 1920s, Sapelo was one of the most active places on the Georgia coast with Coffin's various operations entailing agriculture, timbering and sawmilling, road building, well-drilling, irrigation, the dynamiting and clearing of fields, and his seafood cannery and boatbuilding ventures. These activities preceded the expansion of his efforts to Sea Island beginning in 1926, which resulted in the construction of the Cloister Hotel and resort in 1928.

"Hog City" was built on the southeast side of Sapelo north of the area where the greenhouse was later built. It was only one of Howard Coffin's varied agricultural activities on Sapelo.

Irrigation ditches and canals were utilized to drain Sapelo's swampy, low-lying lands, while also providing water for Coffin's agricultural and livestocking operations.

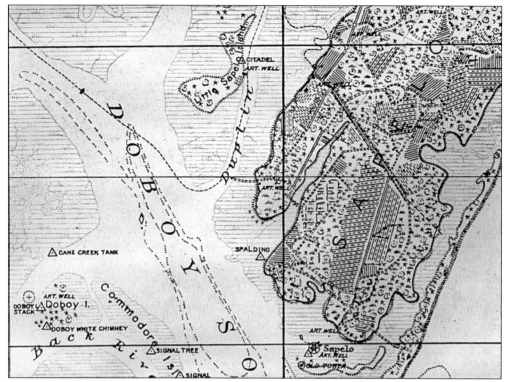

The south end of Sapelo Island fronted on Doboy Sound, the scene of extensive lumber loading operations by international shipping in the generation before Coffin's arrival. The patchwork of agricultural fields is clearly delineated in this 1921 U.S. Army Corps of Engineers map. The lighthouse island is shown, as is the causeway to Marsh Landing.

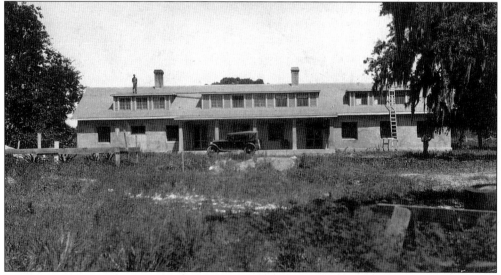

Work was done on the restoration of the Long Tabby in 1921–22. This photo shows the work almost complete, as the second story has been added. The swimming pool in front of the building had not yet been built. The Coffins lived in the Long Tabby for a time while South End Mansion was being restored.

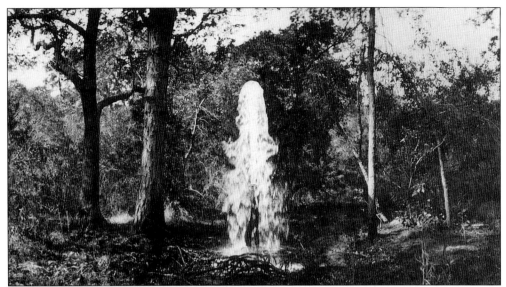

Many deep-ground artesian wells were drilled on Sapelo by Coffin. Pure water from the underground aquifer was the primary water source for most coastal residents and businesses.

Blasting out ditches with dynamite was carried out on Sapelo for Coffin under the supervision of explosives expert Paul Varner. The dynamiting was primarily done to reopen silted-up drainage ditches and canals originally dug by slaves for Thomas Spalding during the plantation period.

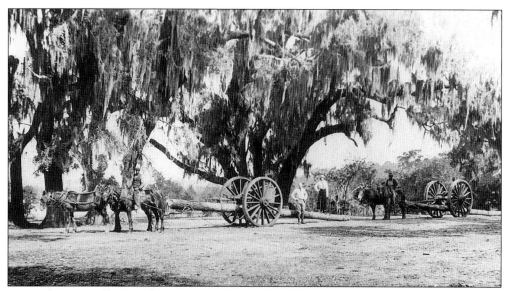

Mr. and Mrs. Coffin are shown posing with large pine logs that are being trundled to the sawmill on Sapelo. Commercial timbering had been done on the island since the Reconstruction era, when some of the former cotton fields were replanted in pine.

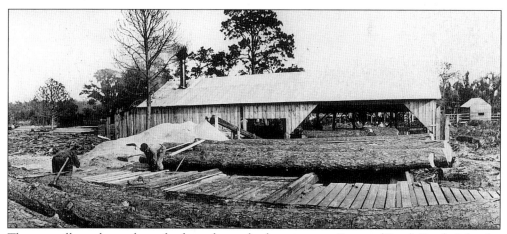

The sawmill was located not far from the seafood cannery on Factory (Barn) Creek. Like the seafood cannery, the sawmill provided employment for many of the island's black residents.

Dynamiting operations in this *c.* 1922 photo are being done at King Savannah in the middle of the island. Paul Varner utilized du Pont dynamite in his ditching work on Sapelo and conducted drainage work according to methods recommended by the du Pont Company. Sapelo was featured in an early 1920s booklet, "Ditching with du Pont Dynamite." The article

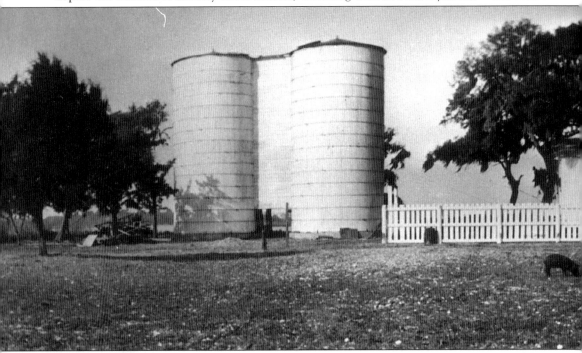

The barn and silos in this photo were built in the early 1920s by Coffin at Kenan Field to support livestocking activities on Sapelo. Cattle and hogs roamed about at "open range" and

noted that King Savannah was "a flat sandy plain . . . where soil conditions are typical of the flatwoods region, dry at the surface, but saturated at the depth for proper loading [of dynamite] . . . A single row of holes 35 inches deep and 22 inches apart was put down by a crew of four men under the direction of a young blaster."

formed a significant portion of Coffin's agricultural operations on the island.

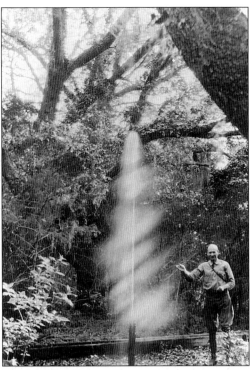

Mr. Coffin is shown posing with one of the many free-flowing artesian wells on Sapelo. During the 1920s there were about 50 artesian wells drilled on various sections of the island.

Workers amid the salt marsh are engaged in unidentified work in the mud flats at low tide. These men may be gathering shellfish or perhaps seining for fish.

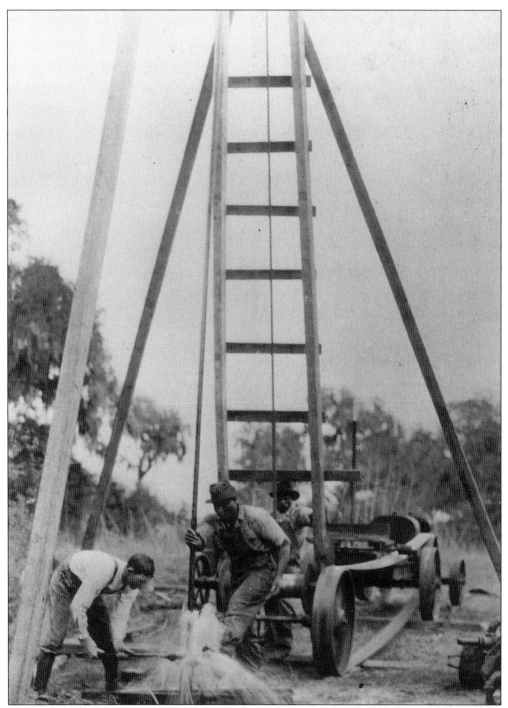

Drilling for water several hundred feet under the surface of the ground was achieved by mechanical means, as exemplified by the machinery in this picture. Here, workers are capping off a recently drilled well. A number of the wells drilled by Coffin continue to be used today. The source of Sapelo's water supply (and that of all of coastal Georgia) remains the Floridan aquifer.

In 1923, dynamiting and artesian well-drilling created the man-made pond just west of South End Mansion. Here, Coffin created a "water garden" with plants and trees, some of them exotic, being installed, with pergolas built to enhance the natural effect. The water garden is still in place but is no longer supplied with free-flowing artesian water.

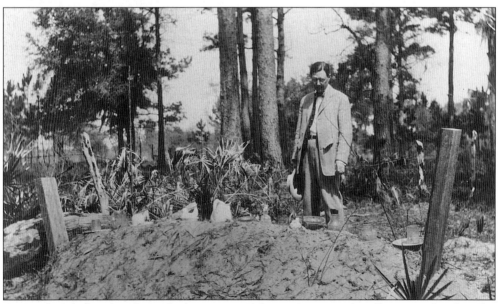

An unidentified archaeologist looks over an African-American burial site on Sapelo. The gravesite is accentuated by ceramic artifacts and glassware displayed atop the burial mound, reflecting a tradition going back to slavery days along the Atlantic coast.

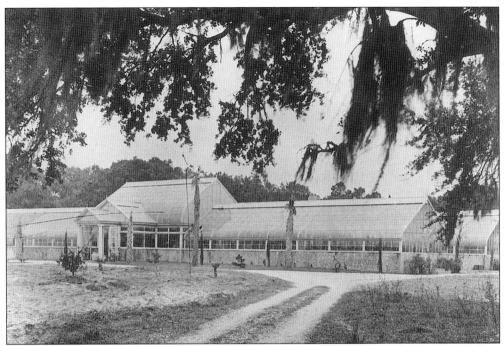

Howard Coffin built the greenhouse in 1925 and hired a gardening staff to maintain the facility. Coffin, like his antebellum predecessor, Thomas Spalding, liked to experiment with plants. He had plants shipped to Sapelo from Latin America and other areas to study their adaptability to coastal Georgia's soil and climatical conditions.

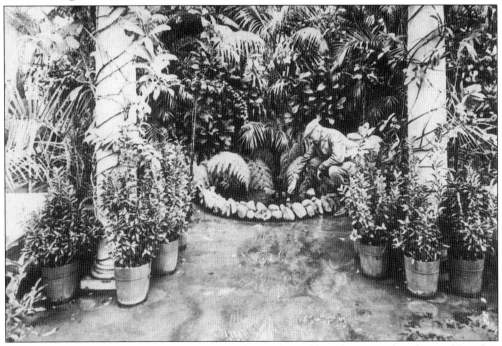

Coffin often worked with his plants, ferns, and trees himself, as shown in this photo of Sapelo's owner inspecting his greenhouse arboretum.

The south end farm complex on the present site of the Marine Institute was built by Coffin about 1919 or 1920. Located here were a barn, stables for horses, and assorted workshops. These wooden structures were later torn down by Richard J. Reynolds, and the present buildings

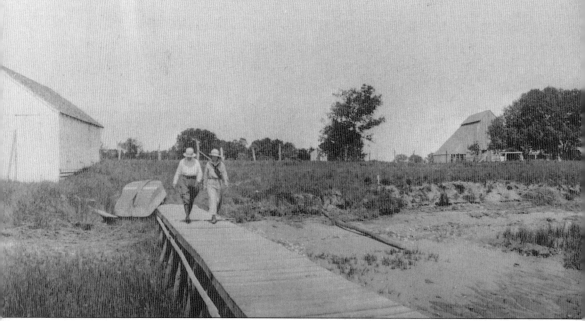

Little Sapelo Island, a marsh island between the Duplin River and Old Teakettle Creek, was the scene of much activity in the 1920s and early 1930s. A Mr. Morgan was hired by Howard Coffin to raise pheasants and chacalaca birds imported from Central America. Coffin built the

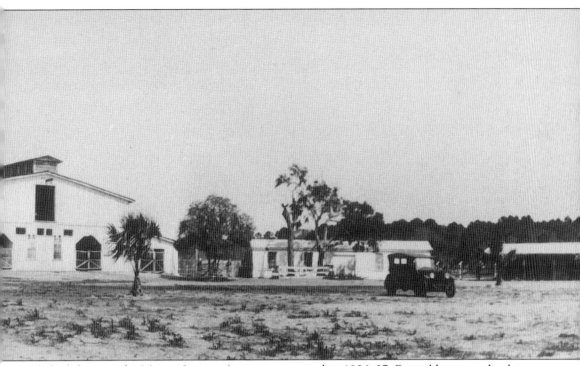

(which became the Marine Institute) were constructed in 1936–37. Reynolds operated a dairy at his new complex and had a large herd of dairy cattle on Sapelo. Milk was processed and sold on the mainland.

frame caretakers house on Little Sapelo, which still stands but has been long abandoned. Bird hunts were conducted on Little Sapelo by Coffin for his guests.

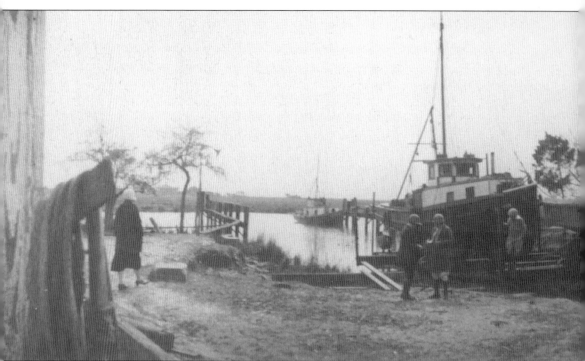

Coffin built a marine railway on South End Creek at the present Marine Institute site to service his fleet of shrimp and oyster boats. This 1924 view, which includes Mr. and Mrs. Coffin, shows the *Cabaretta* and the *Neptune* on the railway. Both boats were built on Sapelo at the south end

The *Miramar*, a houseboat shown at Marsh Landing in this 1922 picture, was Coffin's first large pleasure craft at Sapelo Island. It was the predecessor of the better-known Coffin yacht *Zapala*,

boatyard *c.* 1921 by Emmett Johnson, a black resident of the island. Grant Johnson, Emmett's brother and uncle of Fred Johnson of Hog Hammock, used the *Neptune* to travel to Little Sapelo to tend the cattle there.

built in the late 1920s. Nick Young was Coffin's captain of both the *Miramar* and the *Zapala*.

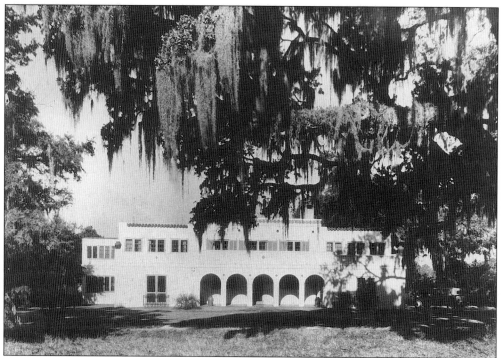

The dormitory and administration building was built in 1922 adjacent to the farm complex and convenient to South End Mansion. Coffin housed his contractors and workers at the dormitory during the rebuilding of the main house. It was here, too, that Coffin and his young cousin, Bill Jones, administered and managed the many operations of the Sapeloe Plantation.

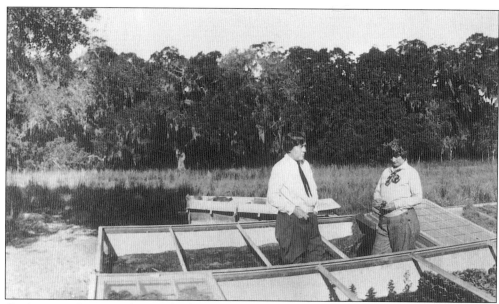

Gardners are shown working with plants in the "cold frames" on Sapelo's south end.

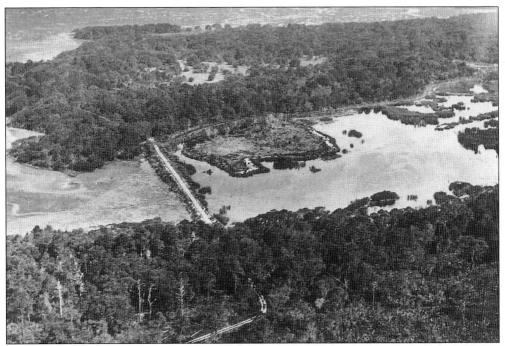

The duck pond was created by Coffin on Sapelo's north end, not far from High Point, about 1924. A dike and causeway were built across the marsh to block the incursion of salt water, artesian wells were dug, and the pond was filled with fresh water. It became a favored habitat for migrating ducks and other waterfowl.

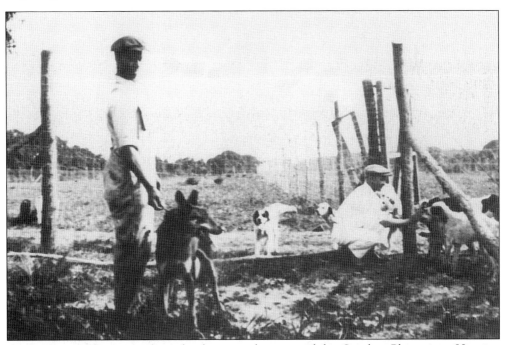

Workmen are shown tending the hunting dogs owned by Sapeloe Plantation. Hunting activities were a popular pastime for the many guests of the Coffins on Sapelo.

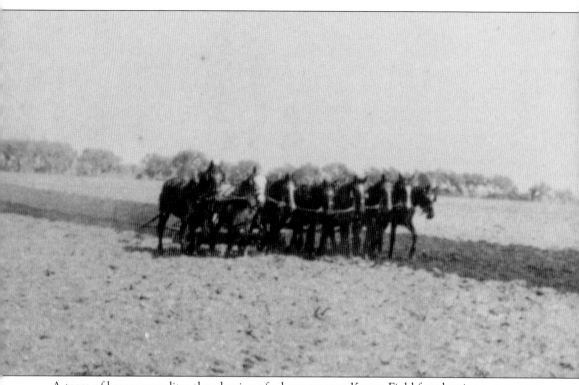

A team of horses expedites the plowing of a large tract at Kenan Field for planting a corn crop. Corn farming was one of the major agricultural activities at Sapeloe Plantation. Coffin also

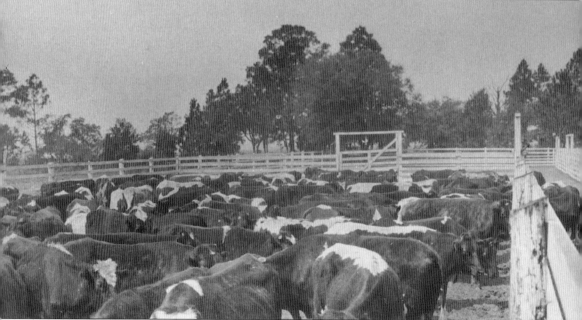

Cattle are being rounded up for "dipping," an activity to reduce the infestation of the cattle by ticks. The cattle pens and dip tanks were located on Factory Creek, west of the present Department of Natural Resources shop. Livestock operations had been part of Sapelo's economy

attempted to revive the cultivation of Sea Island cotton on the island in the years just after World War I. The boll weevil came in, however, and ended the effort.

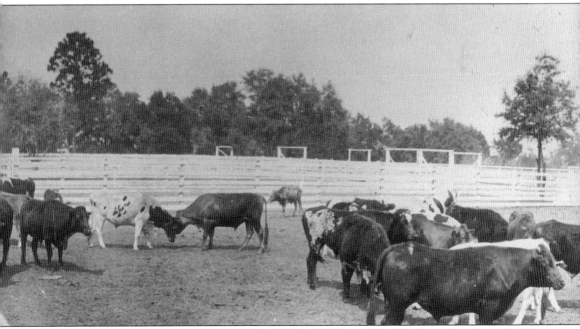

since the days of Reconstruction, when descendants of Thomas Spalding raised cattle and sold their beef to visiting timber ships.

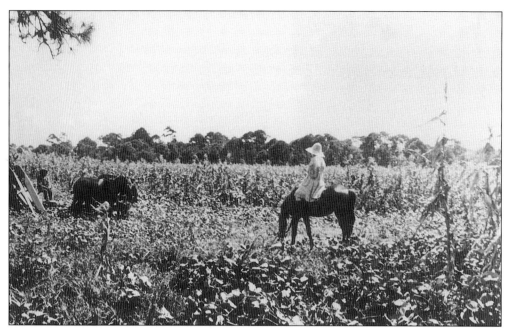

Corn grown at Kenan Field was utilized as silage for hogs and cattle and other Sapelo farm animals, as well as for domestic use on the island.

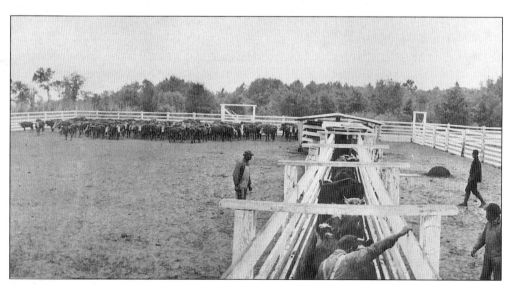

Cattle are run through the chutes toward the dip tanks under the close scrutiny of Sapeloe Plantation workers.

Four

AFRICAN AMERICANS ON SAPELO

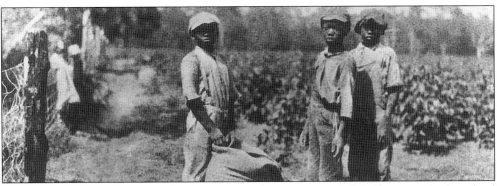

When Howard Coffin bought Sapelo in 1912, there were several settlements on the island occupied by descendants of former slaves. In 1878, Thomas Spalding II, grandson of the island's antebellum owner, began selling land to Sapelo's former slaves. The earliest record of sales of land in what evolved into the present Hog Hammock community on Sapelo occurred on May 10 and September 19, 1878, for land in Shell Hammock. Hog Hammock is a placename dating to the 1840s. It first appeared on a map of Sapelo in 1857. The settlement eventually included the St. Luke Baptist Church (started about 1885), the lodge hall where several groups met, including the Masons, Eastern Star and the Farmers Alliance, a school, residences, and several general stores. Although there has never been a regular, grid-like layout to Hog Hammock, it is shown on an 1891 plat in a similar configuration to that of the present.

Shell Hammock was on the south end, just west of the present Marine Institute. This settlement included dwellings and a praise house. It had disappeared by 1960 as a result of land exchanges with R.J. Reynolds. Behavior was another postbellum black settlement. In plantation days, it had been a slave settlement built around the traditional burial ground and in proximity to the south end cotton fields. Behavior is the only recognizable black cemetery on Sapelo today. Orleans was another cemetery known to have been in use before the 1898 hurricane that apparently destroyed it. Pictured above are Sapelo boys working in a cotton field.

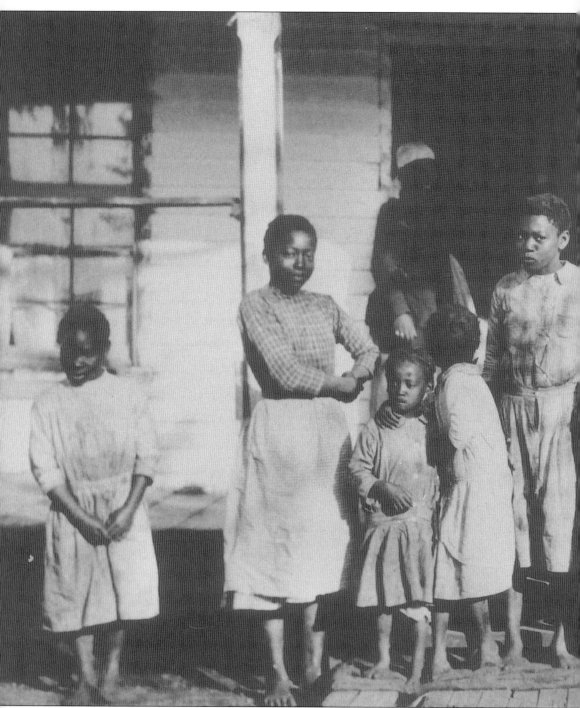

Some of the children of Sapelo are pictured here in the early 1920s. The African-American population of the island numbered several hundred people at one time. In addition to settlements at Hog Hammock, Shell Hammock, Raccoon Bluff, and Behavior, there was for a time a small black community at Kenan Field. This was called Hanging Bull, which evolved from the former slave community at the Kenan plantation. The First African Baptist Church

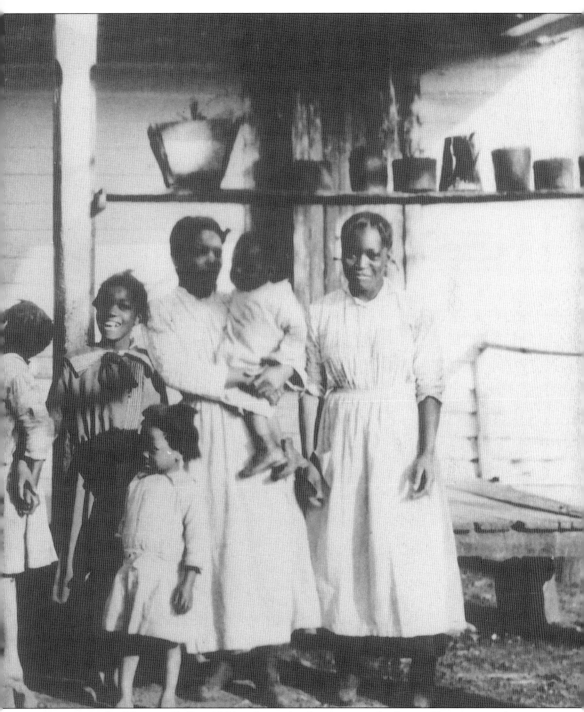

was organized at Hanging Bull in 1866 and is said to have met in the former Kenan cotton barn, the tabby ruins of which are still in evidence on the High Point road. The church and the Hanging Bull settlement moved to Raccoon Bluff following the destruction caused by the 1898 hurricane.

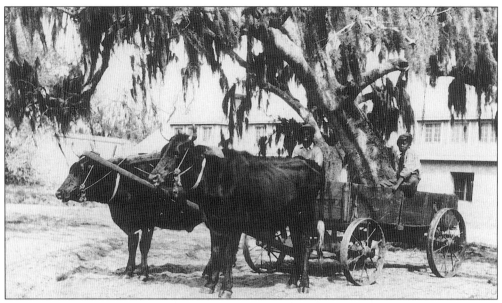

The two boys on the cart are pictured at the Long Tabby. Ox carts were the primary mode of transportation for getting around Sapelo in the late 19th and early 20th centuries.

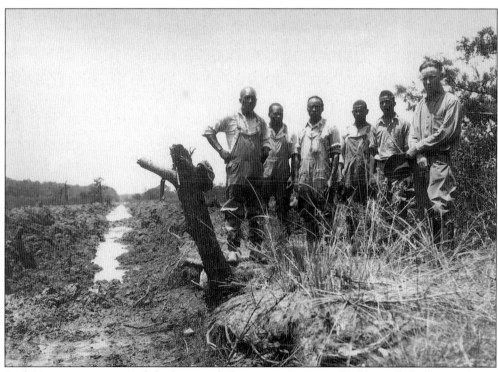

Paul Varner, supervisor of ditching and drainage operations for Howard Coffin, is shown instructing several employees of Sapeloe Plantation.

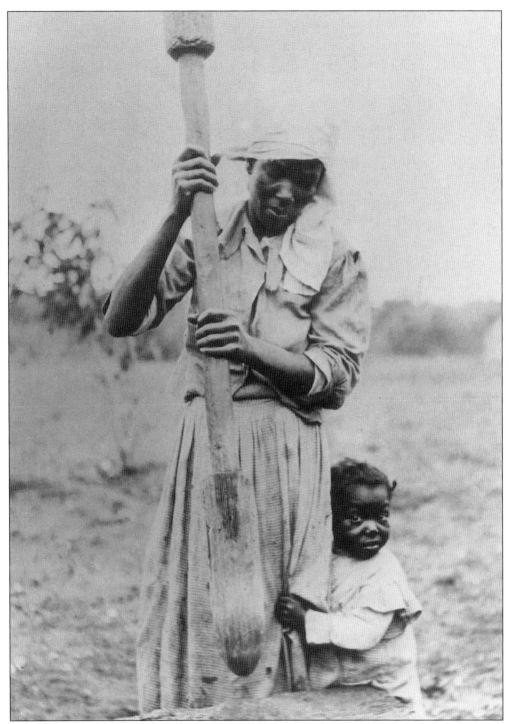

Rachel Dunham is using a wooden pestle to pound rice as her child stays close to her mother and looks somewhat doubtfully at the photographer in this evocative image taken on Sapelo in the early 1920s. Although rice was never grown on Sapelo in large quantities, enough was produced for domestic use by the island's residents.

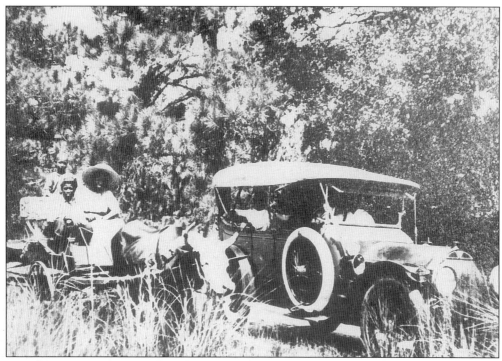

A striking contrast between the "old" Sapelo Island and the "new" is provided in this image of the family on the ox cart alongside one of Howard Coffin's motor cars.

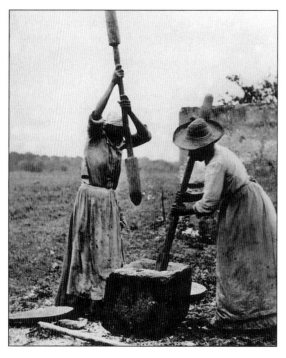

Rachel Dunham and Nancy Jones are pounding rice. The tabby wall in the background of this picture and the one of Rachel on the next page appears to be either at Chocolate or Hanging Bull. In 1885, Amos Sawyer of Massachusetts sold three tracts of land on Sapelo's north end to African-Americans: 60 acres to Caesar Sams (c. 1842–1907) at Lumber Landing, 50 acres at Belle Marsh to Joseph Jones, and a tract to James Green just north of Raccoon Bluff. The Sams property remained in that family until 1956. The descendants of Jones, the Walker family, lived at Belle Marsh until relocating to Hog Hammock about 1950. Green's property reverted to Sawyer in 1890.

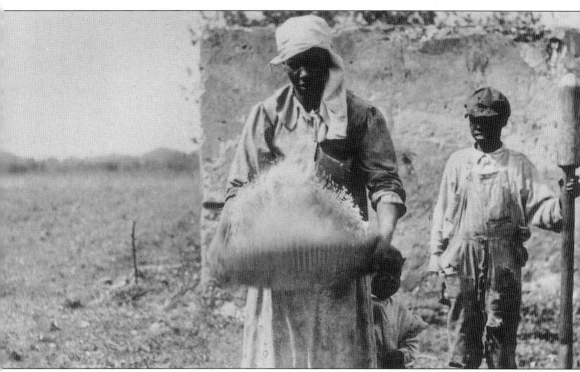

Rachel Dunham is shown using a rice fanner as her children look on. This process allowed the rice husks to be blown clear of the rice. In 1871, descendants of George Street sold 1,000 acres on Sapelo's north end to William Hillery and Company. This was Raccoon Bluff and it became the first black-owned land on Sapelo. This was the only tract on Sapelo never owned by Thomas Spalding. William Hillery was a freed slave and had formed a company with two other freedmen. They sold 20 lots of 33 acres each, with a part of all of them leading to the creek separating Sapelo from Blackbeard. The Raccoon Bluff settlement evolved into the largest on Sapelo. It eventually included a number of frame dwellings, a church, a school, and a general store. After the 1898 hurricane, the First African Baptist Church moved to Raccoon Bluff and a new wood-frame church was built in 1900. There was a school on Sapelo for the children of freed slaves as early as 1868, and another was noted in 1875, possibly at Raccoon Bluff. A Rosenwald School was built at Raccoon Bluff in 1927, the brick chimney of which still stands. The land rearrangements and swaps by R.J. Reynolds resulted in the moving of most of Raccoon Bluff to Hog Hammock in the early 1950s. By 1968, there was no one living at Raccoon Bluff. A new F.A.B. church was built at Hog Hammock. At Raccoon Bluff, only the wooden church remains; it was being restored at the time this volume was compiled.

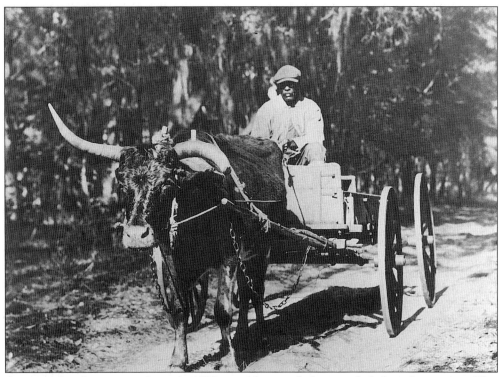

A typical Sapelo scene in the early 1900s would certainly have included ox-drawn carts. This was considered "rapid transit" on the south Atlantic tidewater in the days before automobiles arrived on the scene.

A Sapelo resident inspects a large sea turtle that has made its appearance on the beach.

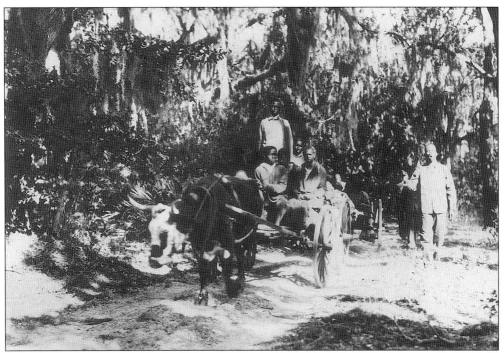

A group of young people proceed along one of Sapelo's sandy roads beneath the oak canopy. The man walking at the right of the picture, who appears to be singing, is George Smith. The boy driving the ox cart is Fred Johnson.

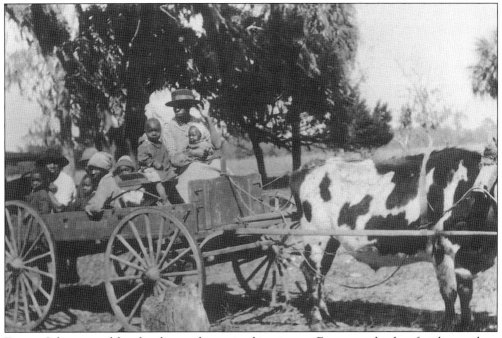

Emmet Johnson and his family are shown in this picture. Emmet and other family members worked for Howard Coffin as boat builders and operators, and also were involved with activities at Coffin's shrimp and oyster cannery on Factory Creek.

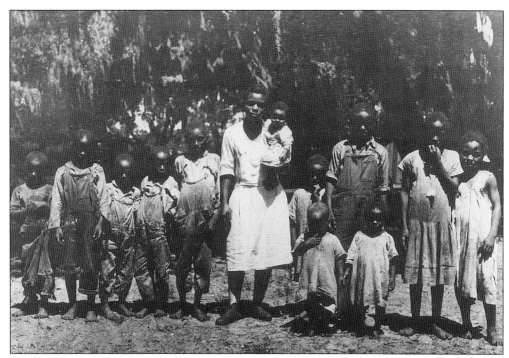

An unidentified family poses for the photographer. Many of the photographs of American Americans on Sapelo were taken by Mrs. Lydia Parrish of St. Simons Island who, in the 1920s and 1930s, researched the culture and traditions of the slave descendants of the Georgia coast.

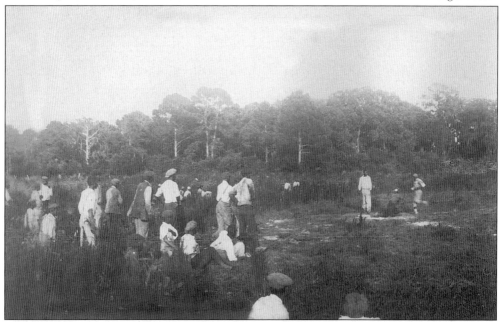

In the 1920s, Sapelo's blacks occasionally played baseball as a recreational pursuit. The local islanders also spent considerable time fishing and hunting, but in those days that was hardly a sporting diversion. Much of the food for the residents came from the woods, home gardens, and the waters around Sapelo, which teemed with fish and shellfish.

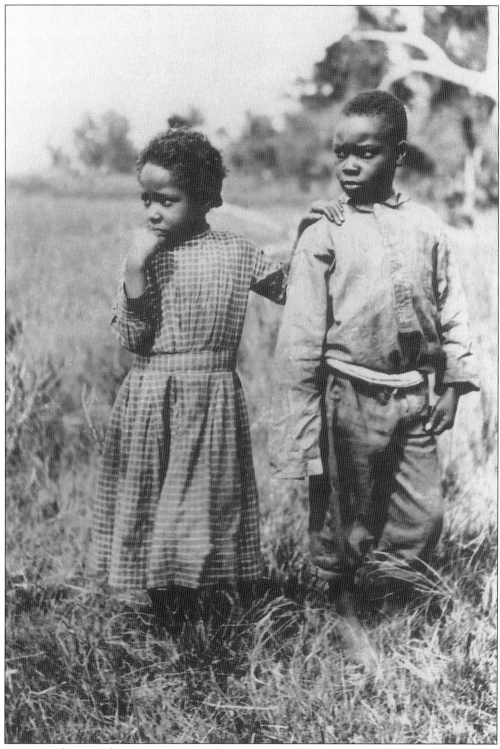

Naomi and Isaac Johnson present a striking image in this unusual, and apparently unposed, photograph probably taken by Lydia Parrish.

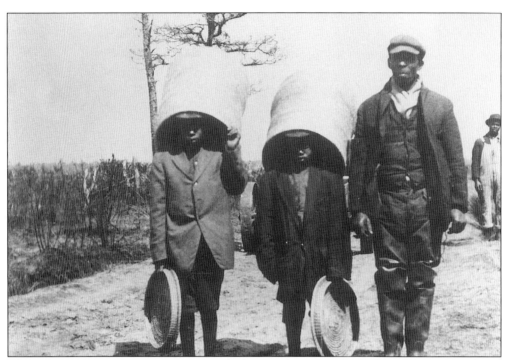

These young men are carrying sweet grass baskets made on Sapelo. Basket weaving is a cultural tradition on the coastal sea islands and continues to be practiced on Sapelo today. The best known of the local basket makers in recent memory was Allen Green, who practiced the art for more than 80 years until his death in 1999. Green lived at Raccoon Bluff for much of his life before moving to Hog Hammock.

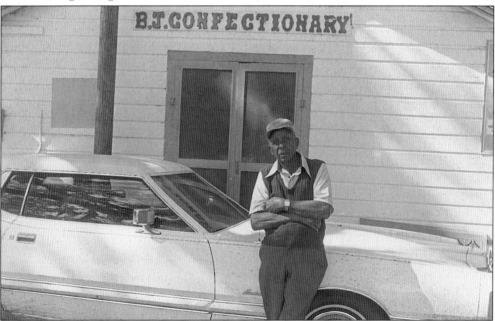

Bennie Johnson worked for R.J. Reynolds as a boat operator, cooked some of the best outdoor barbecue on the coast, and ran the B.J. Confectionery at Hog Hammock.

Five

THE 1920s:

DAYS OF WINE AND ROSES

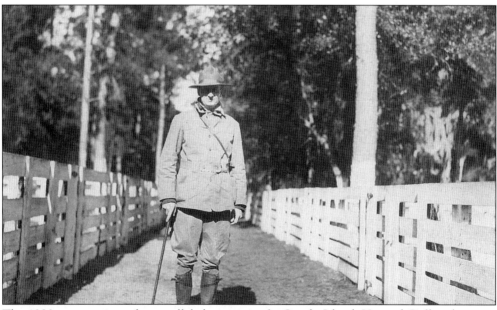

The 1920s were a time of unparalleled prosperity for Sapelo Island. Howard Coffin, shown in his sportsman's habit, had injected huge sums of his fortune into improvements on Sapelo and had provided steady employment for many of the island's blacks in his various ventures. He and his wife, Teddie, embarked on an ambitious plan to completely rebuild South End Mansion to provide a suitable retreat for their many affluent guests on the island. In 1923, Coffin's young cousin, Bill Jones, arrived for a visit and ended up becoming manager of Sapeloe Plantation.

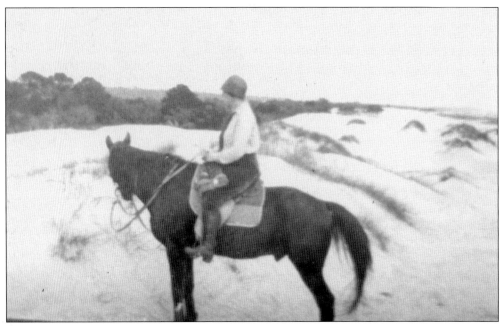

Teddie Coffin enjoyed horseback riding. Here she is shown amid Sapelo's sand dunes.

Spring tides, also known as "marsh hen tides," came on the full moon cycle and flooded Sapelo's salt marshes about 2 feet above normal. This is a scene on one of these tides at the south end. Mrs. Coffin is walking along the small dock, and the lighthouse can be seen in the distance.

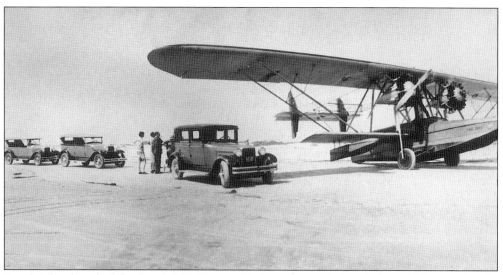

Sapelo's hard-packed flat beach provided an ideal landing strip for planes, which occasionally landed. Here, a float plane is greeted by Coffin and his guests.

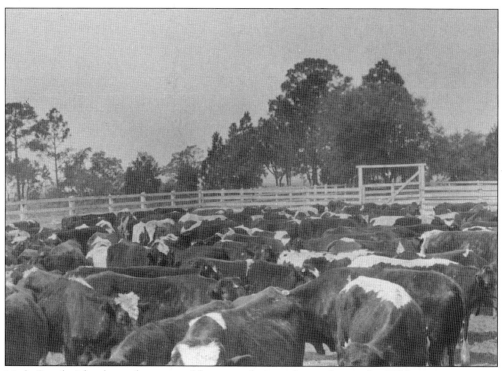

Little Sapelo Island was the scene of frequent pheasant hunts during the 1920s.

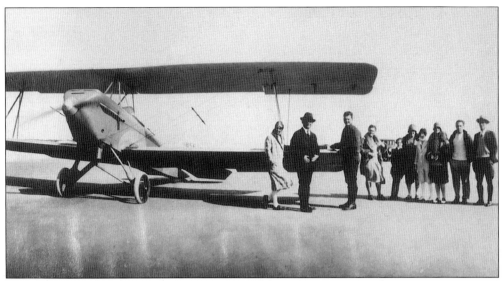

This single-engine biplane is preparing to take off from Nannygoat Beach.

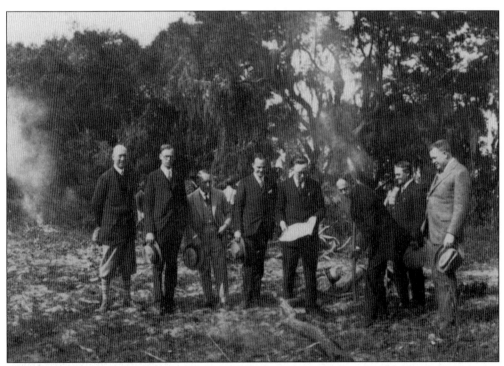

Paul Varner is shown explaining to a group of visitors the methods utilized for land-clearing and ditching on Sapelo. These men may be officials of the du Pont Company of Wilmington, DE, which provided dynamite and technical expertise to Coffin.

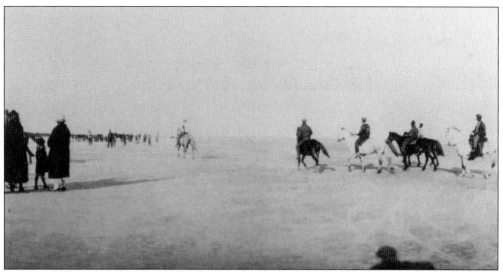

Horseback riding on the beach was a favorite activity for the Coffins and their guests, who came from Georgia and many areas of the eastern United States.

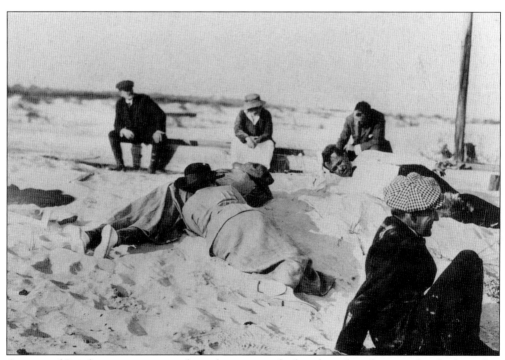

A group of Sapelo visitors enjoys a lazy afternoon at the beach in this photograph, which evokes the casual, carefree, lifestyles reflective of 1920s affluence.

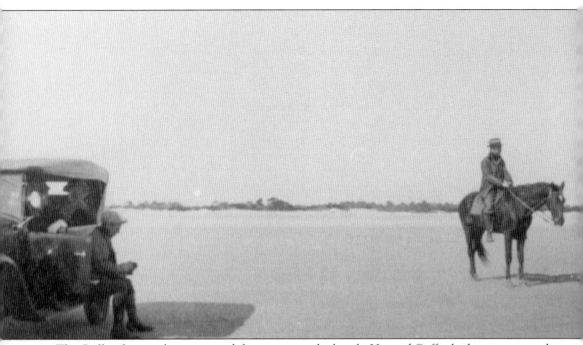

The Coffins frequently entertained their guests at the beach. Howard Coffin laid out a new road from South End Mansion to Nannygoat Beach in the early 1920s to provide more convenient

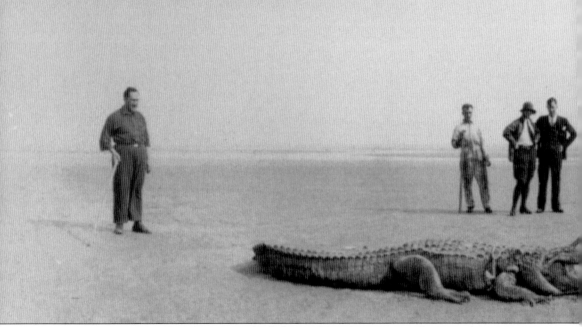

Alligators were often found enjoying the habitat of Sapelo's wet, marshy areas, but it was rare when one of these reptiles found their way to the beach. Alligators preferred brackish water as opposed to a pure saltwater environment. The reptiles were commonly associated with Sapelo's

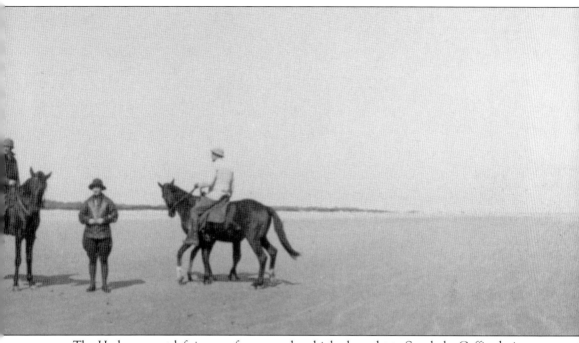

access. The Hudson car at left is one of many such vehicles brought to Sapelo by Coffin during his 22 years of island ownership.

north end around the duck pond and the brackish creeks along the western side of the island. They also began to inhabit the south end water garden.

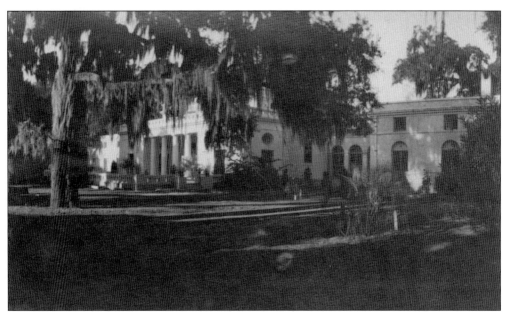

From 1922 to 1925, the Coffins undertook a major restoration of South End House. The majority of the work was completed in 1925, with the interior refurbishment finished by 1927 when the Coffins' guest book reflects a great increase in the numbers of visitors to Sapelo.

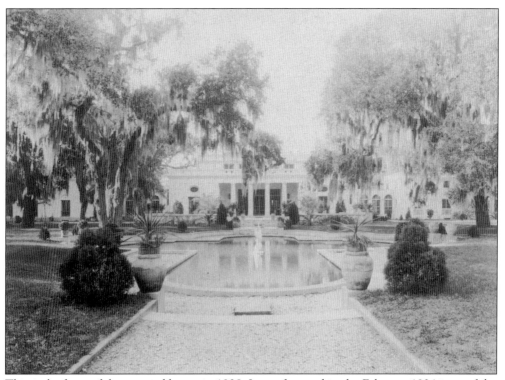

This is the front of the restored house in 1928. It was featured in the February 1934 issue of the *National Geographic Magazine* as part of an extensive article and photos of Coffin's activities on the Georgia coast compiled by W. Robert Moore.

Six

SAPELOE PLANTATION BY LAND AND SEA

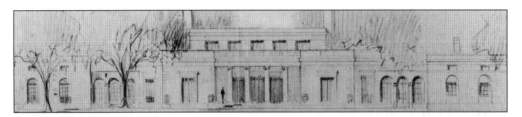

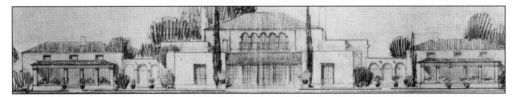

The Coffins decided to rebuild their Sapelo house in 1922 in a style that reflected the antebellum house originally built on the site by Thomas Spalding. The house was completely gutted to a point where only the original tabby walls were left standing. The new house was thus rebuilt almost from scratch. Coffin engaged Detroit architect Albert Kahn to render the plans for his new house. The top drawing is the frontal design that the Coffins ultimately utilized, with the original six columns reduced to four. The lower view by Kahn reflects a Mediterranean exterior rejected by Coffin. The contractor for the house was Arthur Wilson who, in 1927, supervised the restoration of the house on the north end of nearby St. Catherines Island, which Coffin co-owned for a time. Coffin was closely involved with the rebuilding of the Sapelo house. Historian Harold Martin notes that "Coffin would come down to Sapelo [from Detroit] periodically, arriving unexpectedly, to look into every detail of what Arthur Wilson had done during his absence. Frequently, he would order what had been built torn down and done over again. As a result, the house was built and rebuilt about three times before Coffin was satisfied"

One of the best known of all the 1920s photographs of Sapelo is this view of the Coffins' house from the rear, taken in 1928. This and other views of the house were published in the early 1930s in a special "Sapeloe Island Edition" of Sea Island's *Cloister Bells*. Detroit friends of the Coffins, H.N. and Nell Torrey, who were frequent guests on Sapelo, began building a Spanish Revival-style home on Ossabaw Island in 1924. Coffin liked the Torreys' house, and it may

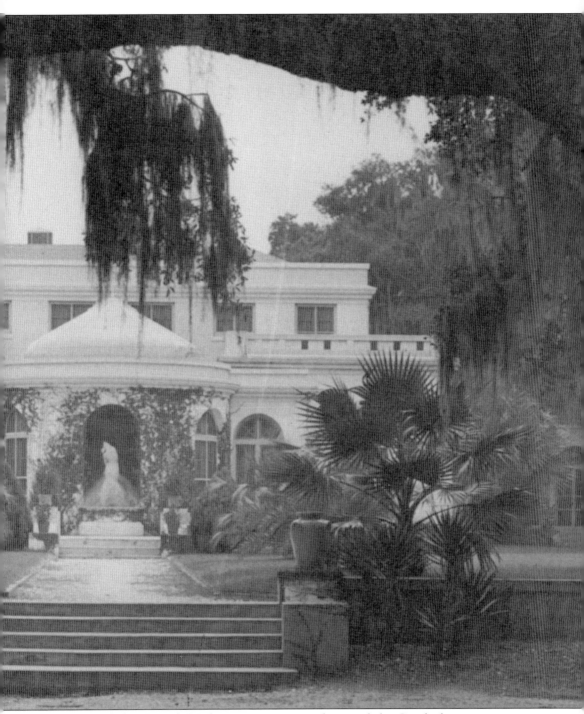

have inspired the Spanish-Mediterranean interior design of the Sapelo house, a concept popular in the 1920s, particularly in the developing affluent resorts in south Florida. After R.J. Reynolds purchased Sapelo from Coffin he engaged Philip T. Shutze (1890–1982), an Atlanta architect, to modify the house to suit his own tastes. The work was completed by the end of 1936.

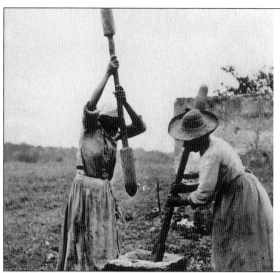

Many of the kitchen fittings of the rebuilt Coffin house are still in place. Above the kitchen are bedrooms used as quarters for the servants and other staff. The 1936 modifications by Reynolds include Shutze's installation of central air conditioning, making the Sapelo house one of the first of the South's "large homes" to be so equipped.

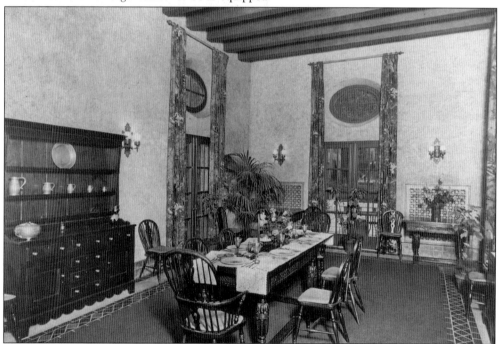

The dining room is seen as it appeared in the Coffin years. Later, Reynolds had Philip Shutze institute many interior changes. Shutze engaged Greek-born muralist Athos Menaboni (1896–1990) of Atlanta to render major works on all three levels of the house. In the loggia (solarium), Menaboni's wall murals reflect tropical birds, plants, and animals. In the basement are paintings of pirates. The Circus Room on the second floor reflects some of the most significant work ever done by Menaboni. This large room was a ballroom in Coffin's era where movies were shown. Reynolds converted it to the circus room in the late 1930s.

Alfred W. (Bill) Jones (1902–1982) oversaw much of the work on the house during the 1920s restoration. He was Coffin's island manager. Later, when Coffin began his ventures on St. Simons and Sea Island, which resulted in the opening of the Cloister resort in 1928, he appointed Jones to direct the day-to-day operations of the project. In 1928, Jones married Katherine (Kit) Talbot. Three generations of the Jones family have guided the affairs of Sea Island and the Cloister to the present day. As Howard and Teddie Coffin had no children of their own, they looked on Bill Jones, almost 30 years junior to Coffin, as a son. Though they were cousins, Bill Jones often referred to Coffin as "Uncle Howard."

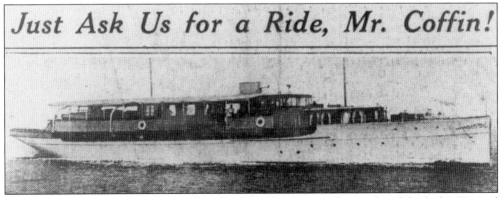

In 1927, the "nation's most palatial yacht," the *Zapala*, was designed and built for Howard Coffin in Connecticut, then delivered to Sapelo. The *Zapala* was a 124-foot vessel suitable for ocean cruising.

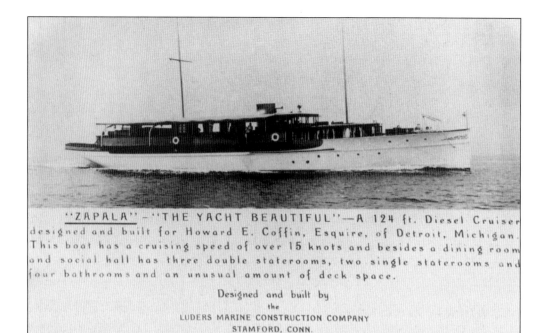

"ZAPALA" — "THE YACHT BEAUTIFUL" — A 124 ft. Diesel Cruiser designed and built for Howard E. Coffin, Esquire, of Detroit, Michigan. This boat has a cruising speed of over 15 knots and besides a dining room and social hall has three double staterooms, two single staterooms and four bathrooms and an unusual amount of deck space.

Designed and built by
the
LUDERS MARINE CONSTRUCTION COMPANY
STAMFORD, CONN.

Coffin's yacht brought President Coolidge to Sapelo in 1928. When Teddie Coffin died on Sea Island in February 1932, her funeral was held outdoors on the grounds of the Sapelo big house. Her casket was then carried aboard the *Zapala* as Sapelo's local residents sang the old spiritual "Shall We Gather at the River." (She was buried in the Christ Church Cemetery on St. Simons Island, as was Howard Coffin when he died in 1937).

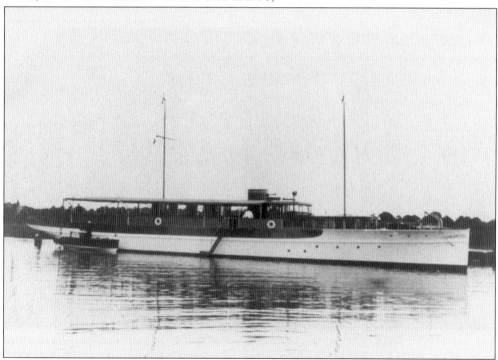

The *Zapala* is shown at dock in this scene, probably at Sapelo's Marsh Landing.

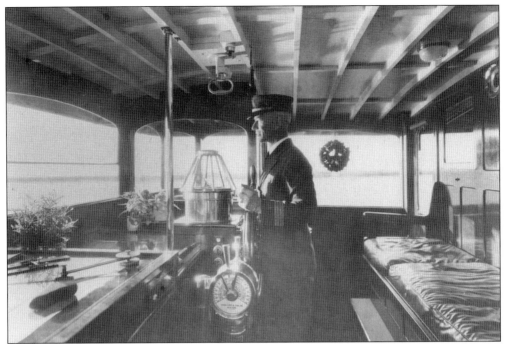

Master of the *Zapala* was Capt. Nick Young, who had been in Coffin's employ for several years. He is shown here at the wheel with the bridge telegraph controls at his left. The *Zapala* was a 159-ton vessel built specifically for Coffin by Luders Marine Construction Company at Stamford, CT. It had a wooden hull and was painted white with decks of teak and cedar.

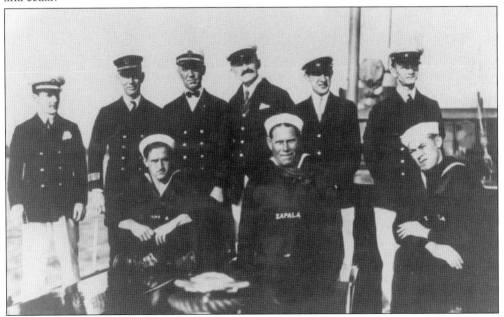

The *Zapala* had a nine-man crew, including Captain Young, an engineer, first officer, three sailors, steward, chef, and mess boy. The crew had its own quarters when the vessel was under way for the Coffins and their guests.

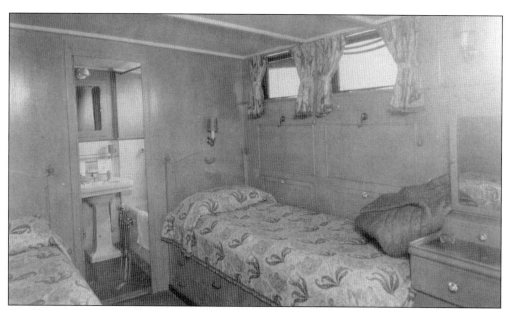

In addition to the crew's quarters, Coffin's yacht had three double and two single staterooms for the use of the owners and their guests. There were four "heads," or bathrooms. Shown is one of the double staterooms with twin beds. These quarters were finished in mahogany, painted in pastel shades, and had full-length mirrors in the doors.

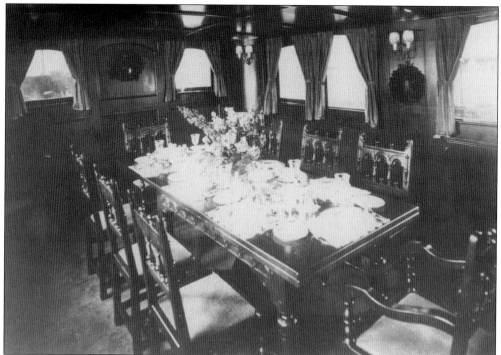

The dining salon was finished in walnut and had a table service for eight. The *Zapala*'s galley was equipped with refrigerators and facilities to prepare any type of meal or snack from the most lavish banquet to a simple lunch. The vessel had copper tanks for 1,500 gallons of fresh water supplied by two automatic pressure pumps. It was state-of-the-art for the late 1920s.

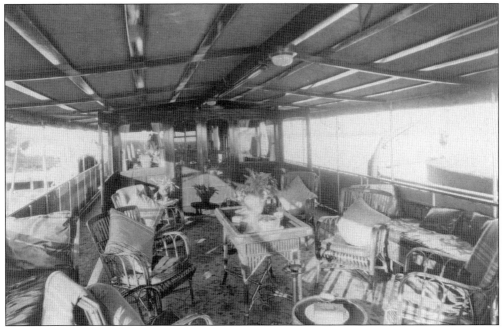

Guests on the *Zapala* could enjoy the scenic beauty of coastal Georgia from comfortable furnishings on the observation deck. There were hinged deck house wings on the after deck and the awnings were of double canvas. There were storage lockers for guns and ammunition as well as fishing tackle.

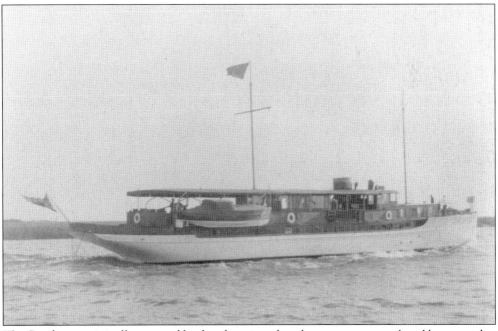

The *Zapala* was originally powered by diesel engines, but these were soon replaced by two eight-cylinder Winton gasoline engines of 350 horsepower each. They gave the yacht a cruising speed of about 17 miles an hour. Fuel capacity was 2,500 gallons. There were two electric winches for hoisting out the smaller powerboat shown in this photo.

SAPELOE PLANTATION

TELEGRAPH ADDRESS
DARIEN, GA.

FREIGHT AND EXPRESS
TOWNSEND, GA.
BRUNSWICK, GA.

SAPELOE ISLAND
SAPELOE, GA.

January 17, 1928.

War Department,
 U.S.Engineers Office,
 Savannah, Ga.

Gentlemen:

 The undersigned, as Manager of Sapeloe Plantation,
for Mr. Howard E. Coffin owner, hereby wishes to make appli-
cation for the erection of a new dock, to be substantially
constructed on palmetto piling with 10x12 creosote caps,
4x12 creosote stringers and decked with 3x10 cypress.

 We attach hereto one tracing paper and four prints
indicating the location of the dock, the elevation and a
plan of the dock itself, showing its relative position,
the flow of the tides and the depth of the water.

 We trust that with this information and the as-
surance from us that the erection of this dock will be no
detriment to navigation, that you will see fit to issue
your permit for this work.

 Very truly yours,

 Niles F. Schuh

 Manager.

Niles F. Schuh.

ASR.

 (3 copies attached)

In 1928, Coffin built an expanded Marsh Landing dock to accommodate his new yacht. This is the dock that has served as Sapelo Island's main landing for over 70 years. The dock house was rebuilt in 1995. The document shown is a 1928 letter from Niles F. Schuh, Sapeloe Plantation Manager, to the U.S. Army Corps of Engineers.

The new Marsh Landing dock called for a wooden deck extending into the Duplin River from the end of the causeway through the marsh. There had been docks at this site since the Spalding plantation days. The 1868 map shown on p. 16 delineates a causeway to Marsh Landing precisely where the Coffin (and present) causeway is.

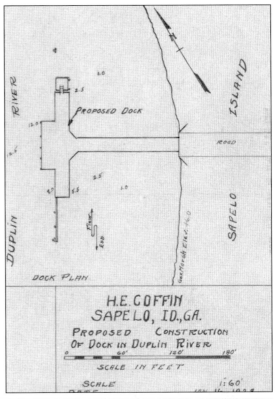

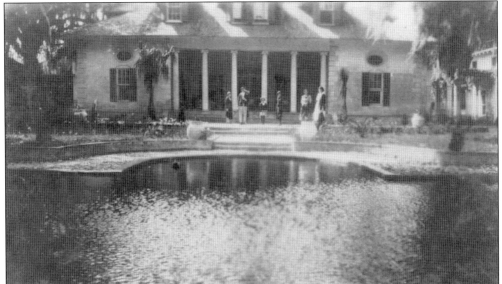

James Cromley (c. 1805–1889), the keeper of the Sapelo Island lighthouse, was appointed to his post by the U.S. Lighthouse Service in 1873. Cromley, an Irishman by birth, and his wife, Catherine, lived with their children at a house adjacent to the 80-foot brick lighthouse tower on Sapelo's south end. When he died, his sons, James Jr. and William, assumed lightkeeping duties. Some of the Cromleys are shown in this photo posing in front of the south end "big house" about 1917.

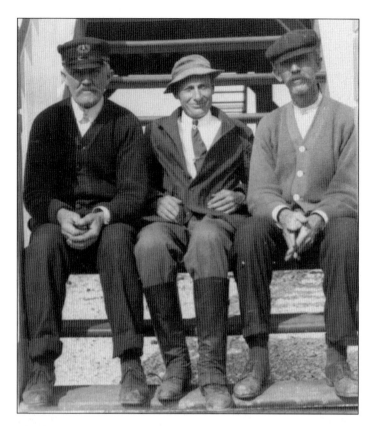

Howard Coffin was greatly interested in lighthouse activities on Sapelo and frequently visited the Cromleys. Here, he sits between James Cromley Jr. (Jimmy) and his son Robert on the steps of one of the keepers' houses. The younger Cromley was the third generation of his family to serve as light keepers on Sapelo. He was the last keeper of the lighthouse before it was deactivated in 1933.

Jimmy Cromley and members of his family pose by the swimming pool at the big house.

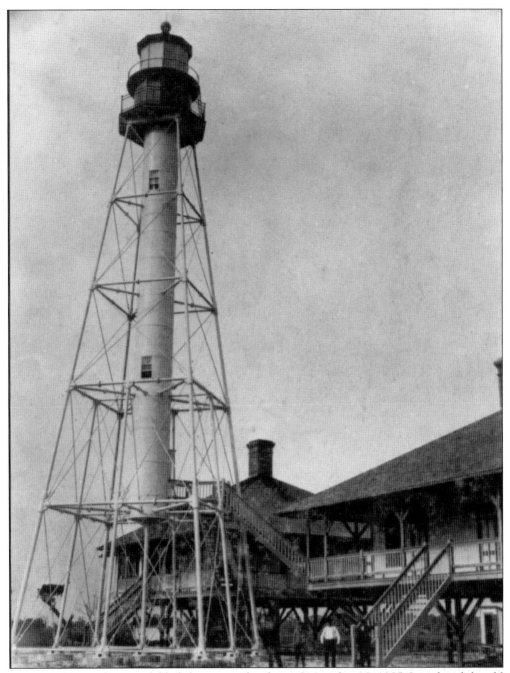

This 100-foot steel pyramidal lighthouse was first lit on September 18, 1905. It replaced the old brick tower several hundred feet away after the latter was damaged in the 1898 hurricane. The new light had a third-order Fresnel lens and was lit by kerosene. There was a brick oil house (still standing) and two attached wood-frame dwellings, one for the head keeper and the other for his assistant.

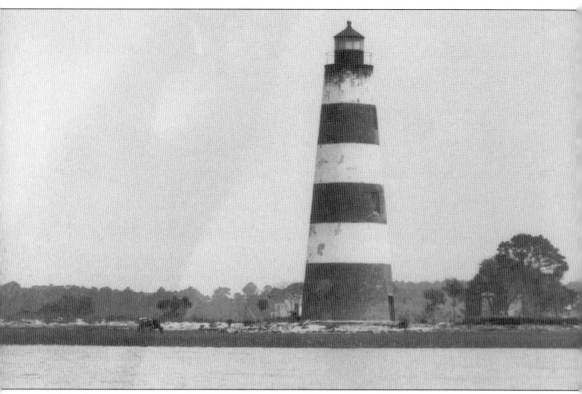

This photo was made in April 1932 from just offshore. The old tower is seen as being much closer to the water than it is today. The new steel tower, further away, is actually 20 feet taller than the old light, although it looks smaller due to the angle. The main island of Sapelo is in

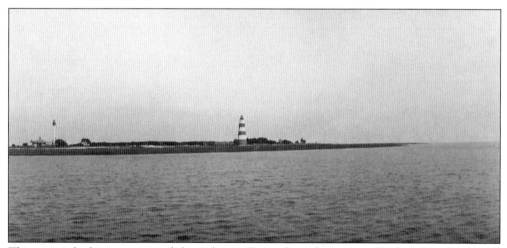

This view is looking east toward the Atlantic Ocean from the waters of Doboy Sound. The old lighthouse, with its alternating red and white bands, is at the right.

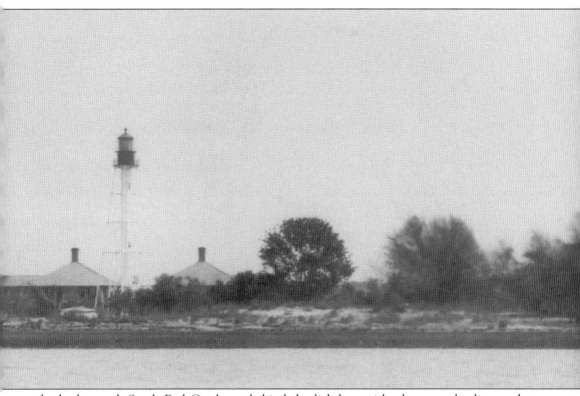

the background. South End Creek ran behind the lighthouse island up to a landing at the present Marine Institute site.

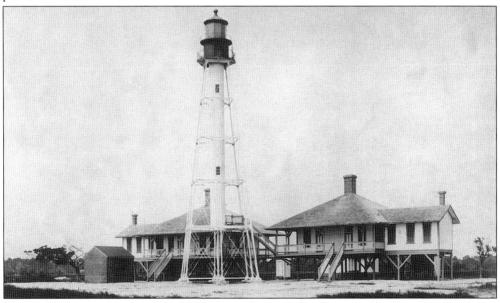

The steel light was deactivated in 1933. It was dismantled and eventually shipped to South Fox Island, Lake Michigan, where it remains to this day. The wooden keepers' houses were torn down and the lumber sold for scrap. The concrete foundations of the tower are still in place, as is the brick oil house.

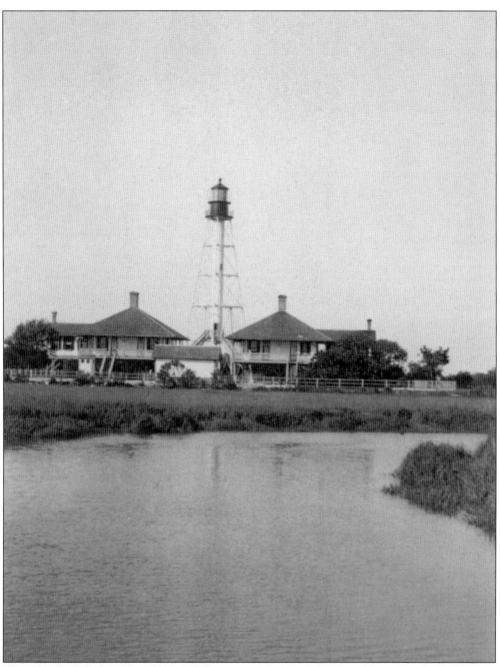

This is an excellent view of the lighthouse and keepers' dwellings from South End Creek, looking south. There was a dock just to the right of this picture from which the Cromleys were able to land supplies and kerosene to keep the light burning. As the shipping going into Darien was greatly decreased in the early 1920s due to the declining timber trade, the Lighthouse Service saw little need to continue operations at the Sapelo Light Station.

Cromley family members are pictured on the porch of one of the houses: notice the outdoor privy near the bottom of the picture. Chickens are also visible near the support piers of the house.

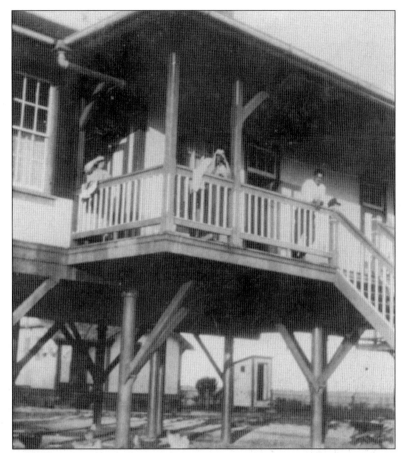

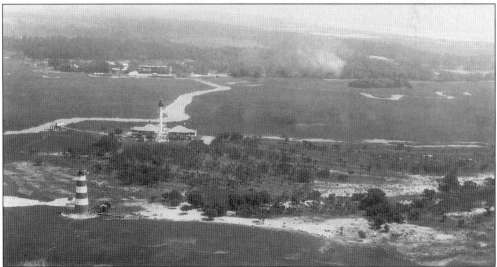

This aerial view of the lighthouse island taken about 1932 depicts both old and new towers. Toward the right is the concrete foundation of the artillery emplacement built by the army in 1898 when the Spanish-American War began. Howard Coffin's farm complex is in the upper part of the picture on the main island of Sapelo.

SAPELO LIGHT
TO BE DARKENED

R. H. Cromley Will Be Re-tired Today

DARIEN, Ga., May 31.—R. H. Cromley, keeper of Sapelo light station, and at one time keeper of Wolf Island light station, will be retired from active duty on June 1, and a strange coincidence with his retirement will be the discontinuance of the Sapelo light station on the same date, after having been in the Cromley family for over 100 years, passing down from father to son.

Mr. Cromley is the only one who has been able to serve the required years enabling him to get a generous pension, for which he is deserving in every way. Mr. Cromley has served

The *Savannah Morning News* reported the deactivation of lighthouse operations on Sapelo on May 31, 1933. Robert H. Cromley retired as the last light keeper, ending 60 years of duties by members of his family. Except for a brief interruption during the Civil War, there had been continuous lighthouse operations on Sapelo since 1820.

Seven

FAMOUS VISITORS

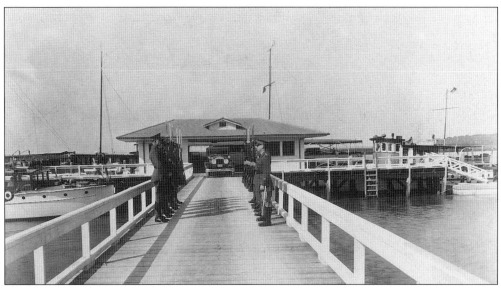

Howard Coffin was an active Republican and was closely connected with key figures in the party. Partly to generate national publicity for his new Sea Island-Cloister Hotel venture (the hotel had opened in the fall of 1928), Coffin invited President Calvin Coolidge and the first lady, Grace, for a coastal Georgia visit. The Coolidges accepted and rode a special train from Washington, D.C. on Christmas Day 1928 and were met in Brunswick on December 26 by the Coffins. The President was closing out his term in office, having not run for re-election in 1928. The Coolidges were brought to Sapelo Island aboard the Coffin yacht, *Zapala*. They are shown being greeted at the Marsh Landing dock by a military honor guard. The Coolidges spent a week as the guests of the Coffins. Most of the visit was spent on Sapelo, but there were trips to Sea Island where Coolidge planted a new oak tree on the lawn of the Cloister, and an outing to Cabin Bluff, Coffin's 60,000-acre hunting preserve in Camden County.

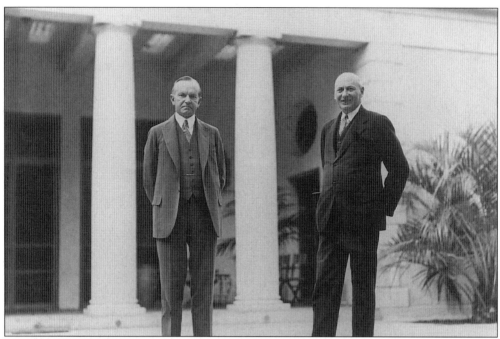

President Coolidge and Howard Coffin are pictured on the front terrace of the Sapelo Island South End House.

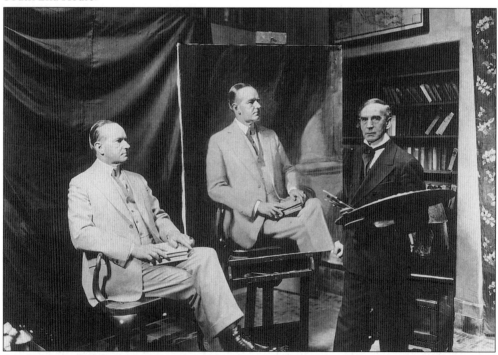

At the time of the Coolidge's visit to Sapelo, well-known English portrait artist Frank O. Salisbury was commissioned to do the portraits of both the President and the first lady. The president is shown in this view with Salisbury and his almost completed portrait. The sittings for both the President and first lady were done in Coffin's library.

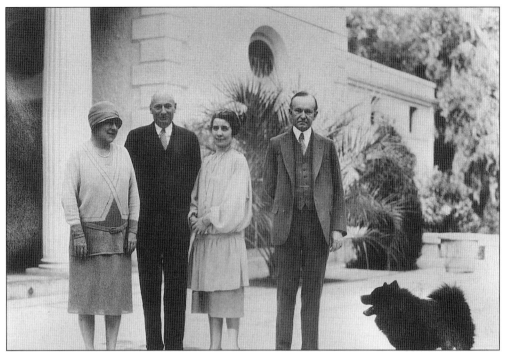

Howard and Matilda Coffin are pictured here with Grace and Calvin Coolidge on the front terrace. A Coolidge smile is difficult to find in this series of Sapelo photographs, but he is said to have enjoyed his sojourn on Sapelo. Also shown in the photograph is Tiny Tim, the Coolidge's dog.

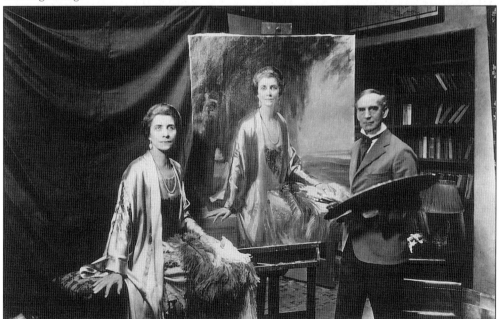

Mrs. Coolidge is shown sitting for her portrait with Frank O. Salisbury. After the Coolidges returned to Washington, Salisbury remained at Sapelo and did the portraits of Mr. and Mrs. Coffin. These now hang on opposite walls of the great room of the Sapelo house.

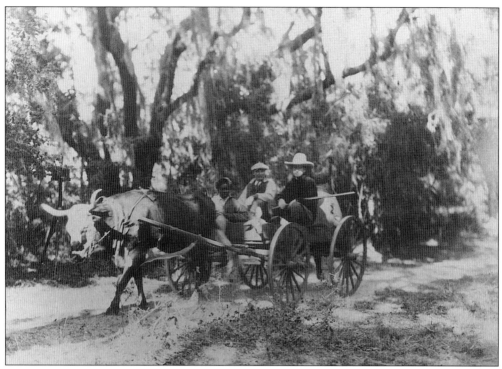

Coffin and the President enjoyed several hunting outings during the visit. Here they are shown riding in from the woods on one of Sapelo's ubiquitous ox carts.

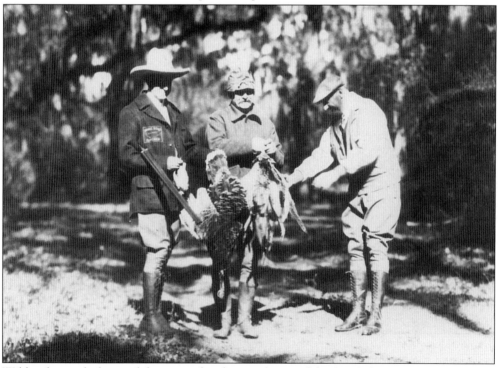

Wild turkey and white-tail deer were the objects of most of the Sapelo hunts.

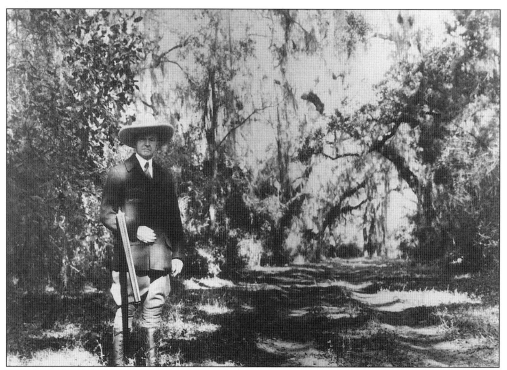

President Coolidge was an enthusiastic outdoorsman, which likely was a consideration in his acceptance of the Coffins' invitation to visit Sapelo Island.

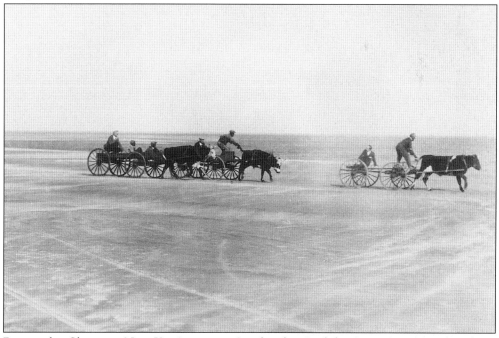

During the Christmas-New Year's visit to Sapelo, the Coolidges were entertained with an "island-style" beach rodeo with island residents as the participants. Here, a spirited ox cart race is in progress.

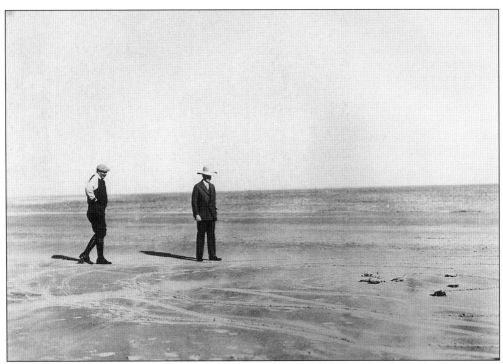

Coffin and Coolidge are shown here watching a turtle race on the beach.

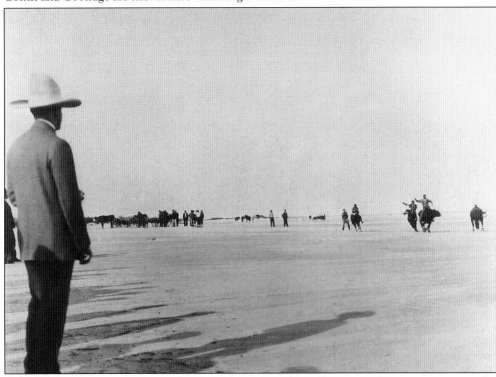

The President, wearing his ten-gallon hat, is shown enjoying the steer-riding competition at the beach rodeo.

The portrait of Howard Coffin done in early 1929 by Frank Salisbury hangs on the north wall in the great room of the Sapelo house. Mrs. Coffin's companion portrait is on the opposite wall. After the sale of Sapelo to R.J. Reynolds, the portraits were moved to the Cloister Hotel where they hung in the lobby until their donation to the state of Georgia by Bill Jones Sr. after the state acquired the island and the main house.

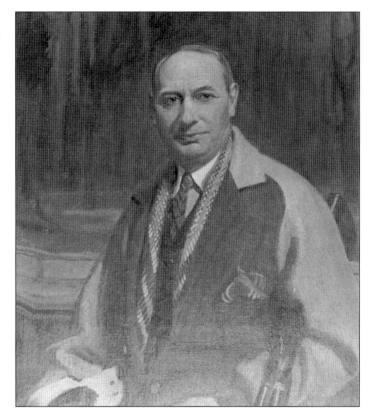

A group of Sapelo hunters is shown posing for a photograph with President Coolidge.

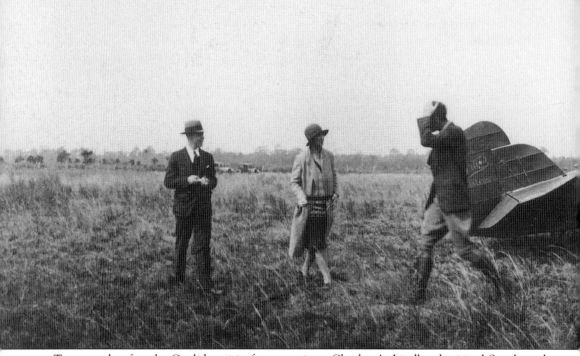

Two months after the Coolidge visit, famous aviator Charles A. Lindbergh visited Sapelo and spent part of a day with the Coffins on February 15, 1929. Lindbergh was en route from Miami to Washington, D.C. He is shown here emerging from his Curtiss single-engine biplane,

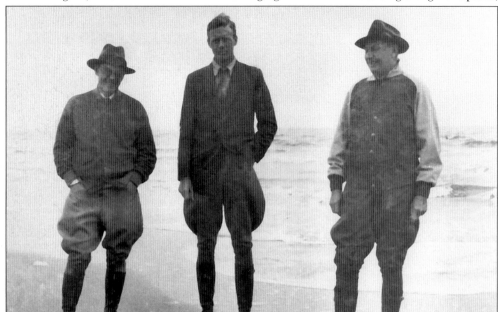

Lindbergh and Coffin often consulted on aviation matters together, which they did at Nannygoat Beach on the afternoon of the aviator's short visit. Flanking Lindbergh are Clement M. Keys (left) and Coffin. Keys and Coffin were long-time Detroit friends and were co-owners for a time of St. Catherines Island, the next large island north of Sapelo.

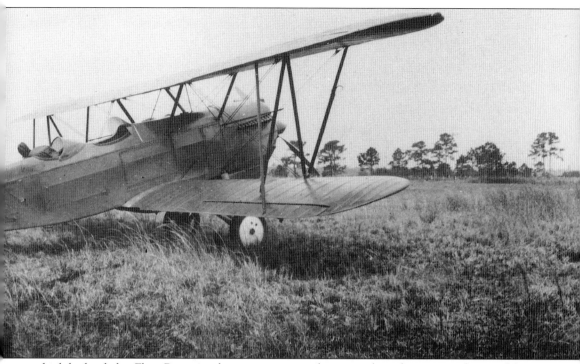

which he landed at Flora Bottoms, then a cow pasture that was a short distance northwest of the Coffin residence.

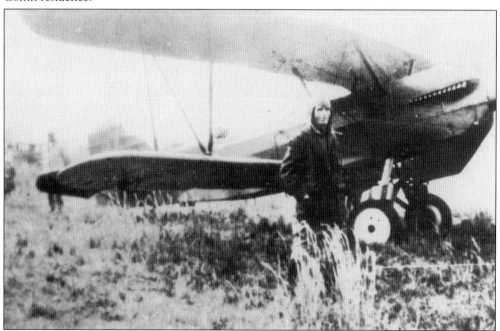

This photograph of Lindbergh on Sapelo is dated 1927, the year Bill Jones Sr. noted as that of Lindbergh's visit. Lindbergh may have visited Sapelo more than once but a close inspection of the picture reveals that Lindbergh's aircraft in this picture is identical to the one pictured at the top of this page in a photo definitely taken during the February 1929 visit.

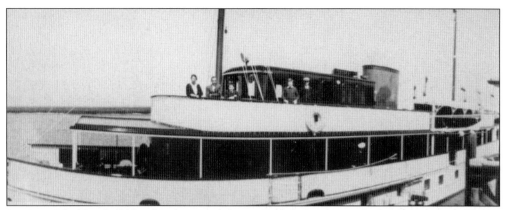

In 1930, Edsel Ford and his family visited the Coffins at Sapelo. Ford's father, Henry Ford, and Coffin had been friends since the earliest days of the automotive industry. In 1925, Henry Ford had come from Dearborn, MI, and begun buying land in the lower part of Bryan County. Ultimately, Ford would own 85,000 acres in Bryan County. There, he pursued many agricultural, medical, educational, and philanthropic activities.

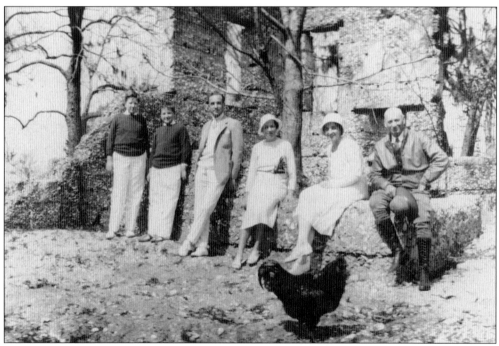

Edsel Ford and his family are pictured with Coffin amid the tabby ruins of Chocolate plantation on Sapelo's north end.

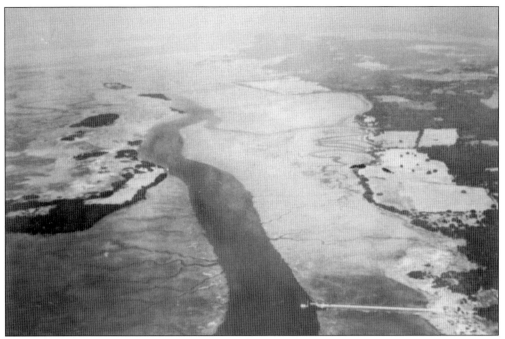

This aerial view is looking north along the tidal Duplin River. Little Sapelo Island is at the left. The Marsh Landing dock and causeway are at the bottom center of the photo.

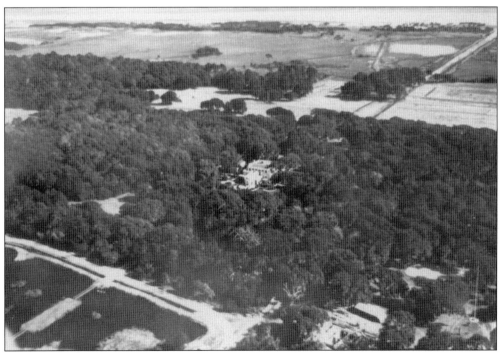

This 1927 aerial view looking east toward the ocean shows the completed South End House in the center. The man-made water garden is at the lower left.

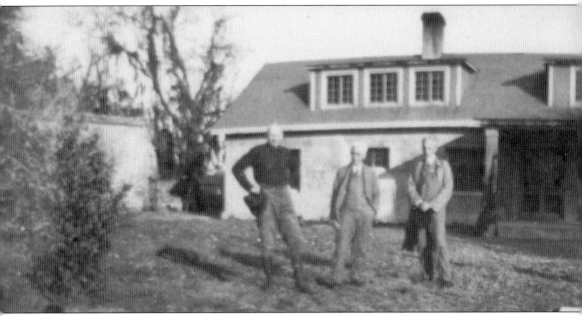

Howard Coffin is shown with Henry Ford (third from left) in front of the Long Tabby guest lodge in 1932. Bill Jones is at the right. The Coffins, Fords, and the Torreys of Ossabaw Island often exchanged visits with each other. Other well-known visitors to Sapelo during the period

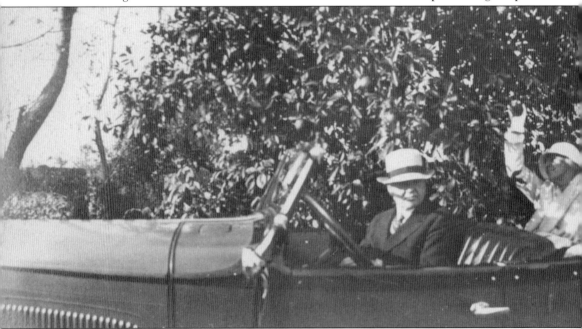

Howard Coffin and President Herbert Hoover were distant cousins and long-time friends. The Coffins had visited the Hoovers at the White House. When Teddie Coffin died of heart failure in February 1932, the first lady, Lou Hoover, attended her funeral on Sapelo and burial on St. Simons. After Hoover's decisive loss to Franklin D. Roosevelt in the 1932 election, Coffin invited the outgoing president to Georgia for a visit. The Hoovers came south on the presidential yacht *Sequoia*. They stopped at Sapelo for dinner and a one-day visit on Christmas

100

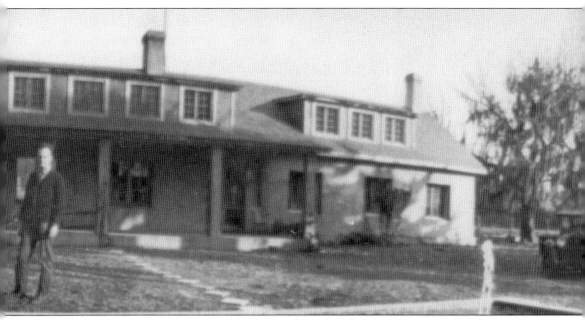

were Clare Booth Brokaw, later Luce (she married the founder of *Time* magazine), golfing great Bobby Jones, textile magnates Cason and Fuller Callaway, and the Carnegie and Ferguson families of Cumberland Island.

Day 1932. Coffin gave the Hoovers an island tour, as seen here, and they were entertained by spirituals and other songs by Sapelo residents. Coffin supposedly made suggestions to Hoover in 1931 and 1932 on ways to ease the Depression (which ultimately cost Coffin virtually all of his fortune). Coffin's ideas were rejected by Hoover, but the two remained close friends. Later, ironically, Coffin noted that some of the programs he had advocated to Hoover found their way into Roosevelt's New Deal.

GEORGIA'S FUTURE AND SOME OF HER UNDEVELOPED RESOURCES

―――――

An Address

BEFORE THE ANNUAL MEETING OF THE GEORGIA BAR ASSOCIATION

The Cloister Hotel

Sea Island Beach, Ga.

By

HOWARD E. COFFIN

Chairman of the Board, Sea Island Company

―――――

Howard Coffin was the principal speaker before the annual meeting of the Georgia Bar Association in 1930, which met at the Cloister Hotel. It was an important speech given before a group of influential people. In it, Coffin extolled the great potential for economic development of coastal Georgia, improvement of living standards and quality of life in the region, and the uniqueness of the coast's culture and historical past.

Eight
A NEW ERA ON SAPELO

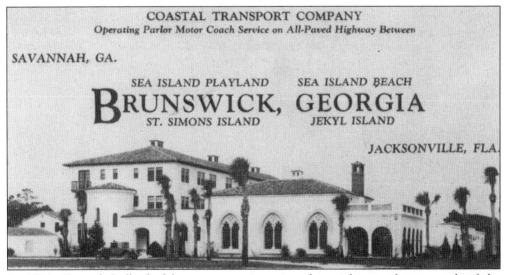

COASTAL TRANSPORT COMPANY
Operating Parlor Motor Coach Service on All-Paved Highway Between

SAVANNAH, GA.

SEA ISLAND PLAYLAND SEA ISLAND BEACH

BRUNSWICK, GEORGIA
ST. SIMONS ISLAND JEKYL ISLAND

JACKSONVILLE, FLA.

By 1931, Howard Coffin had begun to sustain serious financial reversals as a result of the worsening Depression. His investments and real estate ventures had begun to erode, a situation made even more difficult by the burden of loans incurred in financing his projects on Sea Island, St. Simons Island, and Brunswick. His signature project, the Cloister Hotel, is shown in the above advertisement from 1929. In 1932, Coffin decided to sell Sapelo. The buyer was Richard J. (Dick) Reynolds Jr. of Winston-Salem, NC, 28-year old heir to the tobacco fortune accumulated by his father. The sale of the island, including South End Mansion, all the other buildings, and the *Zapala*, was reportedly for $750,000. Most of the negotiations for the sale, which concluded in April 1934, were conducted by Bill Jones, who had by that time begun to handle all of Coffin's business and financial affairs, as well as manage the Sea Island Company. The last date in Coffin's "Sapeloe Guest Register" was June 12, 1934. The sale of Sapelo to Reynolds did not include the seven areas of the island that Coffin did not own: the lighthouse island, Behavior Cemetery, and the African-American settlements of Hog Hammock, Raccoon Bluff, Shell Hammock, Lumber Landing, and Belle Marsh.

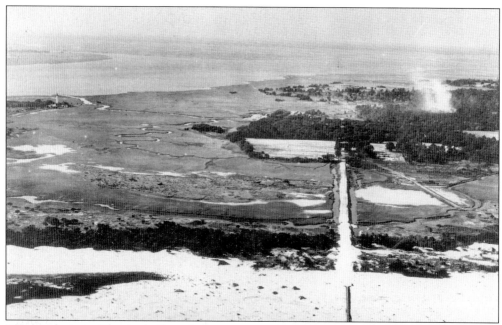

This aerial view of Sapelo, looking from east to west, was taken about the time of the sale of the island to R.J. Reynolds. Nannygoat Beach is in the foreground, with the road leading to the main house. The primary dunes shown here are now the old, secondary, dunes, as the shoreline has accreted and moved about half of a mile further east. The lighthouse and Doboy Sound can be seen at the left of the picture.

Dick Reynolds is shown with his second wife, Marianne O'Brian Reynolds, about 1950. Reynolds was very active on Sapelo during his 30-year ownership. He and his attorneys consolidated many of Sapelo's African-American residents into one community at Hog Hammock in order, it is said, to create a hunting preserve on the north end. All of the north end settlements had been bought out except Raccoon Bluff by the time of Reynolds' death in 1964. Raccoon Bluff was phased out several years after that.

This portrait of Reynolds, which hangs over the fireplace in the great room of the main house, reflects his service as a naval officer in the Pacific campaigns of World War II. Starting in 1936, Reynolds had Atlanta architect Philip Shutze incorporate a number of modifications to the main house, including the engagement of Athos Menaboni to render the murals in three sections of the house. Menaboni also designed a unique Circus Room for Reynolds in the upstairs ballroom. Most of the Reynolds' changes in the house are still in place, including many of the furnishings.

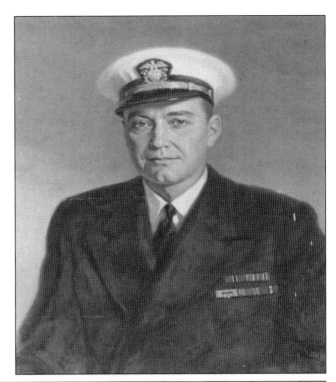

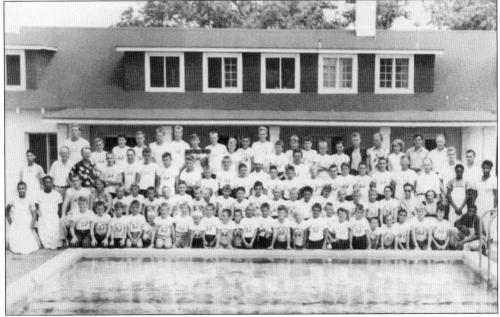

In the late 1940s and early 1950s, Reynolds had a summer camp for underprivileged boys at the Long Tabby. This photograph was made about 1949 in front of the Long Tabby swimming pool. Built on the grounds for the camp were a bunkhouse and a dining hall-kitchen facility. These structures are still in place. The Long Tabby is now the island post office and state administrative offices, while the dining hall has been converted for use as an educational and research classroom and wet lab.

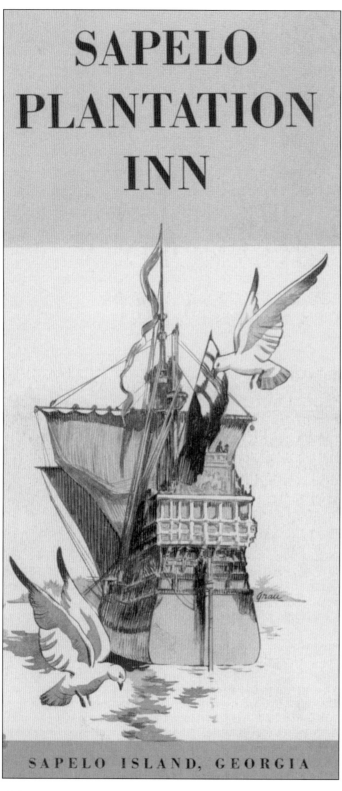

SAPELO PLANTATION INN

SAPELO ISLAND, GEORGIA

For several years in the late 1940s, Reynolds offered the amenities of Sapelo Island to the paying public. The Sapelo Plantation Inn utilized Azalea Cottage, the main house itself, and the present apartment building at the Marine Institute as public accommodations. Guests at the Sapelo Plantation could expect "expert and thoughtful attention given to every detail to make [their] stay comfortable and enjoyable . . . Careful selection of guests assures you of congenial companions during your visit," according to a *c.* 1949 brochure.

Nine

R.J. Reynolds
and UGAMI

In 1936–37, R.J. Reynolds had the wooden barns and stables on the south end, built earlier by Howard Coffin near the main house, torn down with the dairy barn and other buildings being built in their place. This complex was designed by architect Augustus Constantine. For several years, the barn was used to process milk, which was sold on the mainland, while an upstairs theater provided movies to the guests of the Sapelo Plantation Inn. Reynolds also redesigned Coffin's water garden nearby with small islands configured to represent the continents. In 1949, Reynolds began the Sapelo Island Research Foundation, which led to the creation of the marine research laboratory in July 1953, to be housed in the quadrangle buildings. Reynolds invited the University of Georgia to utilize the facilities and coordinate the salt marsh and estuarine research. The first field staff arrived in January 1954. The members of this staff were Dr. Robert A. Ragotzkie, a biologist and hydrographer, and Dr. Theodore J. Starr, a microbiologist. Dr. Lawrence A. Pomeroy, a marine biologist, was added to the resident staff in September 1954. Research in microbiology and hydrography began in June 1954. Thus was born the University of Georgia Marine Institute (UGAMI), which has achieved an international reputation for the significance of its research over the years of its operation.

University of Georgia academic officials, shown above, arrived in 1952 to assess Sapelo's feasibility as a potential site for scientific marine research.

Reynolds, as had Coffin before him, kept numerous cattle in pasturage on the island. Reynolds' dairy business provided employment for a number of island residents, many of whom continued to work for the University of Georgia after it acquired the south end buildings for the Marine Institute.

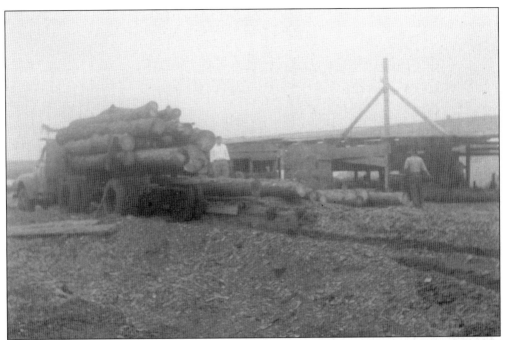

Reynolds continued timbering operations on Sapelo during the 1950s. A sawmill and a barge dock at Lumber Landing on the Duplin River (shown above) facilitated the shipment of timber to the mainland.

This is a 1952 view of a small dock on Barn Creek, probably at Ashantilly Cottage. The view is looking west toward the three Duplin River marsh islands, Mary Hammock, Pumpkin Hammock, and Jack Hammock.

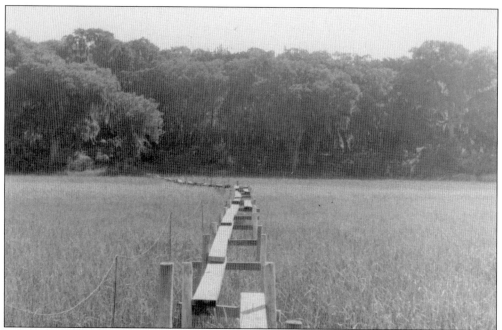

Scientists at UGAMI built wooden access boardwalks through the marsh to expedite their research. This is one of the earliest built, called "Odum's Folly."

In 1949, Reynolds invited well-known archaeologist Antonio J. Waring Jr. to Sapelo to investigate the 4,000-year-old Indian Shell Ring on the north end of the island. Waring and several other archaeologists studied the Native-American ceremonial ring, as well as a number of the island's burial mounds, over the next few years. They expanded on the investigative work begun in 1896 by Philadelphia archaeologist Clarence B. Moore.

This view of Little Sapelo in the mid-1950s shows that the island has become considerably more overgrown than it was in the Coffin years. Compare this view with the *c.* 1927 picture on p. 42.

Nannygoat Beach is seen in a 1950s view at low tide. The piling at left, and three others like it, were reportedly installed by Reynolds to hang nets to protect guests of the Sapelo Plantation Inn from potential sharks in the area.

This photograph, taken in 1956, shows a UGAMI experimental research site in the high marsh at the mouth of Barn Creek. In the background is Mary Hammock on the Duplin River.

A small tidal creek provides a quiet setting amid the salt marsh for a UGAMI researcher.

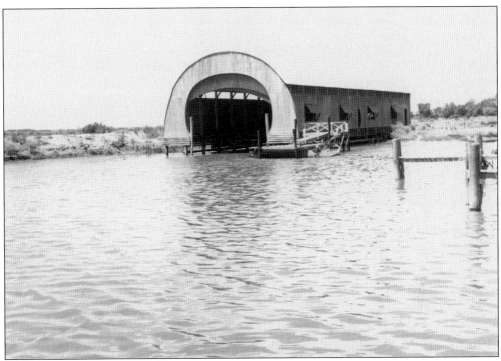

This covered boat shed on South End Creek at the Marine Institute was utilized to house the growing assortment of research vessels in the 1950s.

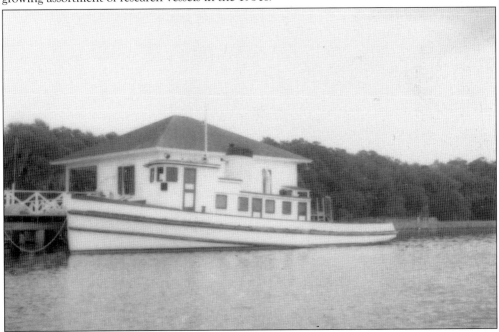

In 1939, R.J. Reynolds engaged the New York firm of Sparkman and Stephens to design the towboat *Kit Jones*, named for the wife of Alfred W. Jones of Sea Island. The 65-foot *Kit Jones* was built on Sapelo and launched in 1940. In 1955, Reynolds provided the boat to UGAMI for use as a utility vessel in its field work.

Announcement
of
Research Assistantships
in
Marine Biology
1955-56

University of Georgia

Marine Biology Laboratory
Sapelo Island, Georgia

The research program at Sapelo, according to this 1955 brochure, "was aimed at the general problem of biological productivity of an estuarine environment . . . Biologically the waters [at Sapelo] are very rich and up to the present time they have been essentially untouched by scientific investigation." Early facilities included "a sea water system and aquaria, an air conditioned room, a cold room, an autoclave, well-equipped chemistry and microbiology laboratories . . . [and] equipment for collecting water, plankton samples and bottom mud . . ." In 1955–56 there was a staff of three at the Marine Institute.

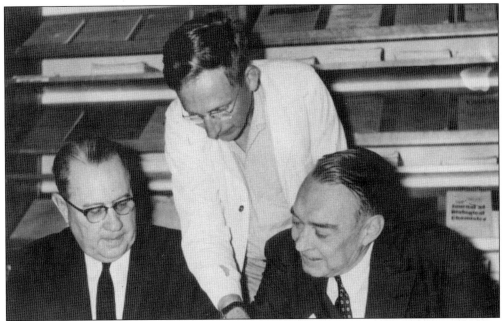

This *c.* 1959 photograph was taken in the library of the Marine Institute. Pictured, from left to right, are O.C. Aderhold, president of the University of Georgia; Professor Eugene P. Odum, who guided the early work and direction of the research at the Institute; and R.J. Reynolds, who made possible the creation of the facility.

Pictured, from left to right, are some of the first scientists at UGAMI: Lawrence R. Pomeroy, Herbert Kale (?), Eugene P. Odum, and Donald C. Scott. Other contributors to the work of the Marine Institute in the 1950s and early 1960s were John M. Teal, Robert Ragotzkie, A.E. Smalley, John Hoyt, Vernon Henry, Theodore Starr, George H. Lauff, Orrin Pilkey, and James Howard.

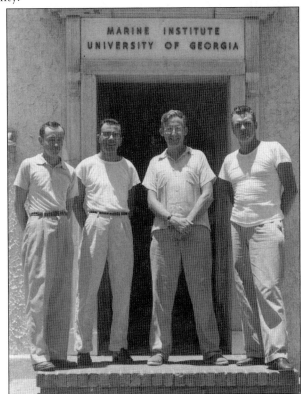

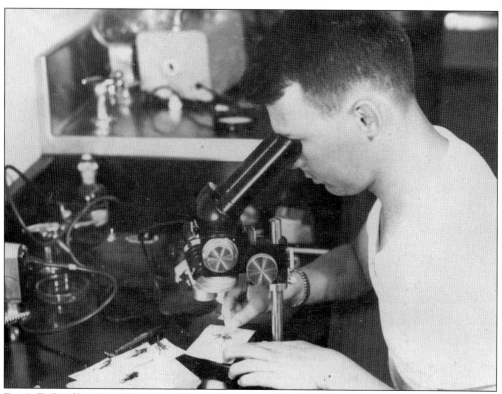

Dr. A.E. Smalley is studying a marsh grasshopper in this 1959 photograph.

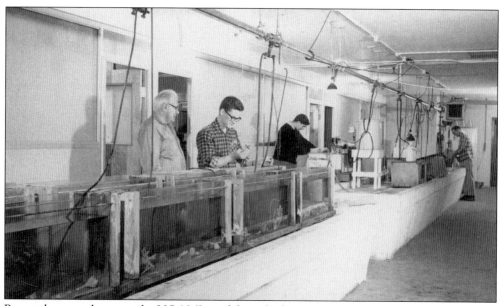

Researchers are shown in the UGAMI wet lab in the late 1950s. These saltwater tanks were on the ground level of the former dairy barn, which was becoming the main research facility at the Marine Institute.

PROGRAM

CONFERENCE ON SALT MARSHES

at

The University of Georgia Marine Institute

Sapelo Island, Georgia

25-28 March 1958

Sponsored by The National Science Foundation and

The University of Georgia Marine Institute

The Conference on Salt Marshes, held on Sapelo Island in the spring of 1958, was one of great significance in the field of ecological and estuarine marine science. About 50 scientists from Georgia and other states along the East Coast participated in the four-day meeting.

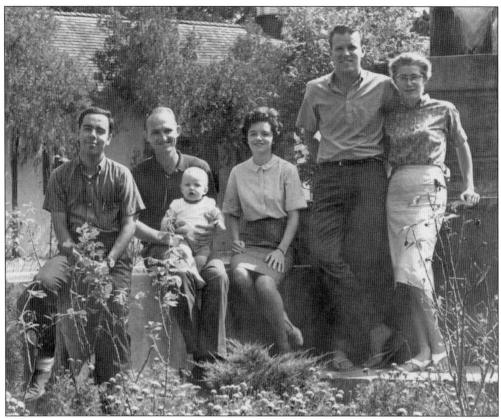

These are young scientists at the Marine Institute in the late 1950s. Unfortunately, the files of the UGAMI contained no identifications for the young people shown here.

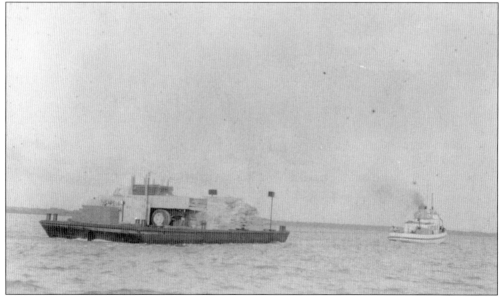

The *Kit Jones* is shown towing a barge laden with what appears to be building materials over to Sapelo Island.

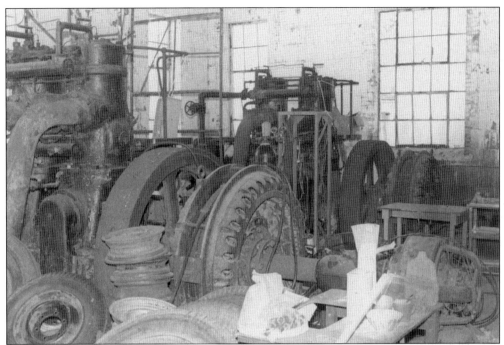

In 1936, R.J. Reynolds had a new generator house built on South End Creek near the Marine Institute. The equipment and machinery pictured here, long after it had fallen into disuse, provided the electric power for the south end of Sapelo throughout the 1940s and 1950s.

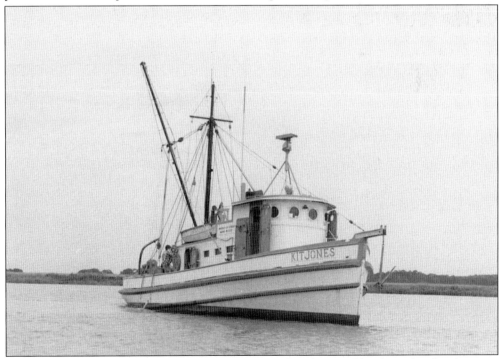

This view of the *Kit Jones* from the early 1960s shows that the vessel has been fitted with a mast and outrigger boom for trawl nets.

SAPELO ISLAND GEORGIA '54–'55

progress report

THE UNIVERSITY OF GEORGIA

MARINE BIOLOGY LABORATORY

This is the cover of the progress report covering the first full year of operation, 1954–55, of the Marine Institute at Sapelo. This document states, in part, that "to build the necessary fund of basic knowledge we must begin, not merely by pondering over the love life of the oyster or the wanderlust of the shrimp, but with the microscopic creatures that are the basic food on which all other marine animals depend."

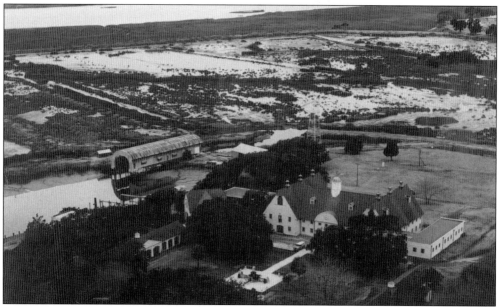

The grounds of the Marine Institute are dominated by the two-story former dairy barn in the center of this *c.* 1960 photo. The boathouse is to the left. In the background are the diked marshes, an earlier project of R.J. Reynolds.

The buildings on the quadrangle opposite the main laboratory were quarters for Sapelo Plantation Inn guests in the late 1940s. When research began at the Marine Institute in 1954, this building provided the early resident housing for the scientists. This picture was taken in 1955.

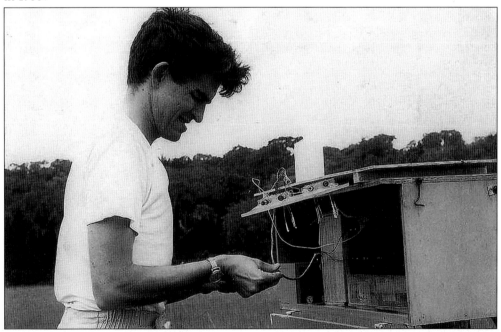

John M. Teal was a young research scientist at the UGA Marine Institute from 1958 to 1962. He pursued energy flow studies whereby estimates were made of the efficiency with which the ecosystem harnesses and consumes energy, thus greatly expanding the understanding of how the salt marsh functions. His natural history observations added depth to the growing information base about Sapelo and barrier islands in general. In 1964, he and his wife Mildred wrote and published *Portrait of an Island*—still a classic study of the natural history of Sapelo.

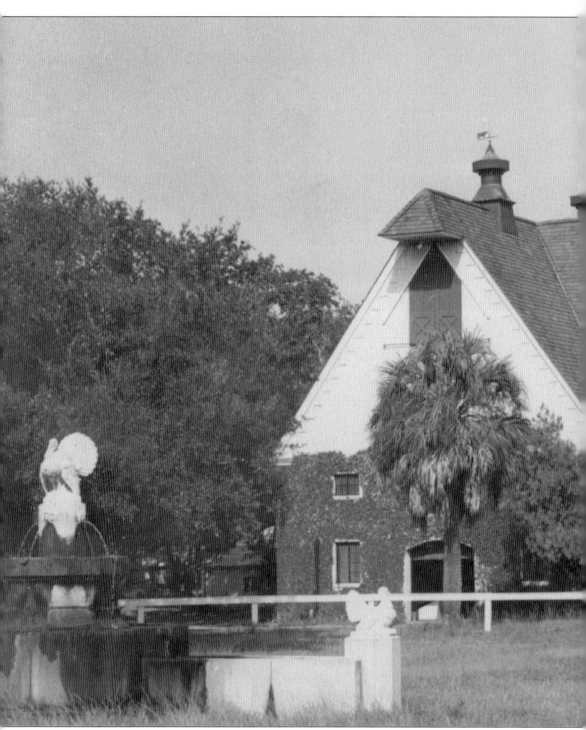

This 1955 photograph shows the dairy barn as it appeared in the first full year of the operation of the Marine Institute. Notice the famous turkey fountain built by German sculptor Fritz Zimmer at the behest of Reynolds c. 1937. Artesian water is flowing from the fountain. Many stories, some quite farfetched, have developed over the years about the turkey fountain, which,

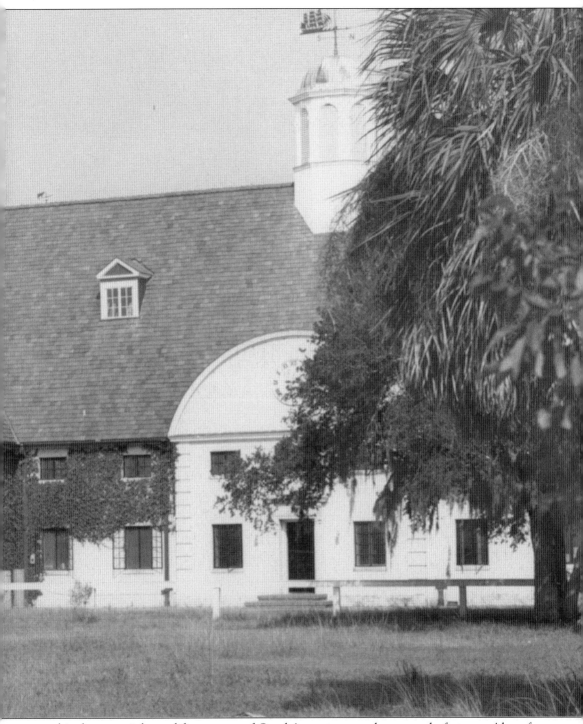

to this day, certainly qualifies as one of Sapelo's most unusual man-made features. Also of interest in this view is the ivy that covers part of the facade of the laboratory building. It has long since been removed.

This serene black-and-white view from the early 1960s captures the essence of Sapelo: a moss-draped live oak hangs over a placid tidal creek and its salt marshes, with cedar hammocks in the background. This is a scene which transcends all of the human experience on this unique Georgia sea island—Native American, Spanish missionary, colonial trader, antebellum planter, African slave, automotive pioneer, tobacco heir, and marsh researcher. There would have been very little different about a scene such as this to any of these, except the changing color of the marshes and the migrating waterfowl.

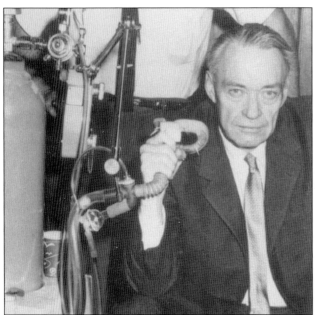

By 1962, when this picture was taken, R.J. Reynolds was a sick man, suffering from emphysema. He is shown here at the McIntosh County courthouse in Darien on the occasion of his second divorce trial from his third wife, Muriel Greenough Reynolds. The first divorce trial occured in 1960. In April 1961, the 55-year-old Reynolds married 31-year-old Annemarie Schmidt. A successful appeal by Muriel resulted in the second divorce trial.

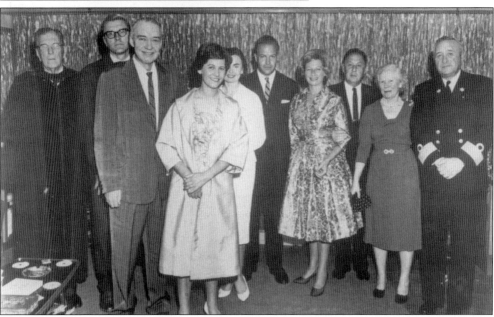

The couple in front is Dick and Annemarie Schmidt Reynolds on the occasion of their 1961 wedding aboard a cruise ship in the South China Sea. Reynolds and Annemarie lived in virtual seclusion until his death in December 1964 in Switzerland. Annemarie Reynolds ensured the preservation of research and the African-American community on Sapelo by selling the upper two-thirds of the island to the state of Georgia in 1969 as the R.J. Reynolds Wildlife Refuge. In 1976, the Sapelo Island Research Foundation, at the behest of Mrs. Reynolds, sold the south end of Sapelo to the state. This acquisition was partly funded by a federal grant, and the land became the nation's second national estuarine sanctuary, managed by the state Department of Natural Resources and administered by the U.S. Department of Commerce. Jimmy Carter became the third president to visit Sapelo while in office. He came to Sapelo in 1979.

RICHARD J. REYNOLDS

June 20, 1963

Mr. John Timothy Schroder
2628 Habersham Road, N.W.
Atlanta 5, Georgia

Dear Tim:

It was very good to have your letter and to hear
how much you enjoyed Sapelo last year.

Although you letter makes no mention of it, you
no doubt had an opportunity to visit the Marine Institute while
on the island and to learn of the interesting program of the
many types of research that is being conducted there. I have
recently been informed that several parasites, which had never
been known before anywhere, were found on the island.
Such findings invariably cause a great deal of national and
world-wide interest and, together with the overall results
of the research activities, we have been able to make some
highly valuable contributions to science over the past years.

This year, too, we have quite an impressive
roster of visiting scientists--as well as conferences on end--
and if it weren't for lack of accommodation and laboratory
space, we might have one of the biggest operations of its
kind. I certainly hope that you had a glimpse of the institute
when you were on Sapelo.

Thanking you again for your thoughtful ness in writing
me, I am,

Sincerely,

Richard J. Reynolds

This June 1963 letter is likely one of the last documents written by R.J. Reynolds regarding
Sapelo Island before his death the following year. The pride he takes in the scientific work
being conducted on his island is apparent.

INDEX